REMARKABLE
WOMEN
of
Old Saybrook

REMARKABLE
WOMEN
of
Old Saybrook

TEDD LEVY

Charleston — London

THE
History
PRESS

Published by The History Press
Charleston, SC 29403
www.historypress.net

Front cover: Top left: Ann Petry. Courtesy of Stephen Dunn/The Hartford Courant; *top right*: Maria Sanford. Courtesy of University of Minnesota Archives, University of Minnesota—Twin Cities; *Middle*: Katharine Hepburn. Portrait by Everett Kinstler. *Bottom left*: Emily Ingham. Courtesy of LeRoy, New York Historical Society; *bottom center*: Kathleen E. Goodwin. Portrait by Robert Childress; *bottom right*: Marion Hepburn Grant. Courtesy of Katharine Houghton Grant.

Back cover: The Hepburn House. Courtesy of Old Saybrook Historical Society.

First published 2013

Manufactured in the United States

ISBN 978.1.60949.866.5

Library of Congress CIP data applied for.

Dedicated to those who advance human opportunity.

CONTENTS

CONTENTS

FOREWORD

As Tedd Levy's editor at the *Shoreline Times*, each week I eagerly look forward to his lively, local history columns that not only educate but also entertain the reader. While he writes on many subjects, Levy's women of Old Saybrook seem to come alive on the page.

We can picture "Goodie," with her coiffed hair, taking the bus at night to earn her bachelor's and later master's degree in education in New Haven, catching a nap before her stop on the way home after a late class and having enough energy to start a student harmonica band. (Former pupils who were soldiers in World War II wrote her to tell her that playing the harmonica offered them comfort from the loneliness and fatigue of combat.) All this was in addition to her teaching a full course load during the day to both high school and middle school students.

In Levy's *Remarkable Women of Old Saybrook*, we learn even more about Goodie, who became the beloved principal of the elementary school and got around town on her black bicycle, stopping to chat with her students. The Kathleen E. Goodwin Elementary School was named after her while she was still alive, much to her amazement.

Although not as famous as Susan B. Anthony, Katharine Houghton Hepburn, mother of the legendary actress Katharine Hepburn, was a suffragette whose activities were controversial among those in her "polite society." Hepburn, along with others, organized the Hartford Political Equality League to battle for women's right to vote. She found that group too tame and joined a more militant group founded by Alice Paul, the National Women's Party.

And there was Anna Louise James, the first black woman pharmacist in Connecticut, who took care of a community and served them ice cream sodas while dispensing medicine and good advice at James Pharmacy. But don't forget her niece, Ann Petry, an African-American writer who wrote the classic novel *The Street* in 1946, which was published again in 1992 and became a best seller. *The Street* is the story of a single African-American mother in Harlem and her struggles in raising her eight-year-old son "amidst poverty, crime, human conceit and deceit."

Then there was the group of Saybrook women who wanted to connect the community and its sons and daughters during World War II. Led by Anne Sweet, the group produced "Saybrook Sez," a local mimeographed newspaper containing five pages of hometown news for servicemen overseas that became the Facebook of the 1940s, according to Levy. The editors asked readers to "send in everything you think will interest some of the other fellows you know who are not with you." Soon, they were receiving letters from around the world.

These are just a few of the remarkable women of Old Saybrook as remembered and researched by local historian Tedd Levy. Levy, a member of the Old Saybrook Historical Society, most recently coauthored the local history book *Old Saybrook: Postcard History* with Barbara Maynard, former Old Saybrook first selectwoman.

In *Remarkable Women*, we see local restaurateur Steffie Walters, who came to this country from Austria, at the helm of the much-loved shore eatery, the landmark Dock and Dine in Old Saybrook. As a widow, she expanded her tourist-friendly business to include a miniature golf course and a take-out seafood shack next door, run by her daughters. Generations later, the Dock and Dine is still a shoreline destination for folks from near and far.

We also get the inside scoop on one of the stickiest divorces in the nineteenth century, which involved one of the famous Hart sisters, Sarah Hart. The divorce was finally granted by the Connecticut General Assembly—after a second try. There is also the infamous story of Jeannette Hart's engagement to Simon Bolivar, which was incorrectly reported by newspapers all over. The story included a mistress, a miscarriage and the transport of a dead body by sea while a war raged on a continent. In fact, this Hart sister never stepped foot in South America. She did, however, become an early novelist.

While all these women were very different from one another, they all showed spunk or spirit. Some defied social conventions of the day, and they worked to make their community and the world a better place. In Levy's world, women are not the gentler sex; he seeks women who made a

difference—women who shook things up a bit. Levy sums it up best himself: "These women lived remarkable lives because they lived purposeful lives. They broke barriers, expanded opportunities, overcame adversity and made important contributions. As a result, they left a legacy of a better future, not only for other women but for all of society."

<div align="right">
Susan Braden

Editor, *Shoreline Times*
</div>

ACKNOWLEDGEMENTS

Well-deserved recognition goes to a number of people who have helped with this work. Special thanks go to Anne Sweet and Margaret "Bucky" Buckridge Bock, who are largely responsible for maintaining the records in the Old Saybrook Historical Society archives. They not only know the resources but also have an incomparable and immensely valuable recollection of the past and cheerfully and patiently share their knowledge and skills.

Thanks also to Linda Kinsella, past president of the Old Saybrook Historical Society, who drew on her knowledge and acquaintances to suggest resources and arrange contacts that were otherwise unknown or unavailable. And great admiration and appreciation for Barbara J. Maynard, who is always willing to share and promote the history of her hometown with everlasting energy and enthusiasm.

Thanks to Bob Czepiel for sharing photographs; Roy Lindgren for his consistent willingness to share postcards; Bonnie Robinson Cook for sharing pictures and memories; Lynne Belluscio and the LeRoy, New York Historical Society for readily sharing their knowledge and resources; and Stephen Dunn, *Hartford Courant* photographer, for allowing us to reproduce his outstanding images of Ann Petry.

Our special gratitude goes to Elisabeth Petry and Katharine Houghton Grant, remarkable women in their own right, for their willingness to share photos and observations about their distinguished mothers.

Special recognition and appreciation go to the eminent artist Everett Ray Kinstler for his generosity in allowing us to use his exceptional portrait of Katharine Hepburn.

We especially appreciate the interest, expertise and personal goodwill of Susan Braden, editor of the *Shoreline Times*, who has published essays about Old Saybrook history and willingly agreed to write a foreword to this publication.

Special gratitude to Ann Gamble, a talented freelance writer based in Old Saybrook, for the use of her article about Barbara J. Maynard. Thanks also to Elizabeth Kenney, assistant dean of the School of Graduate Studies at Salem State University and an accomplished historian and able educator, for her important work on the life of Jeannette Hart.

And thanks to a remarkable partner, my wife, Carol.

INTRODUCTION

Old Saybrook is a small town on Long Island Sound at the mouth of the Connecticut River and is influenced both historically and geographically by a seventeen-mile shoreline. Long the home of various Native American nations, it was briefly explored in 1614 by the Dutch and settled in 1635 by the English, who built a fort.

From those earliest days until recent times, farming, fishing and trade were important economic activities. Beginning in the second half of the nineteenth century, its location on the coast attracted summer visitors, many of whom became part-time residents. Over the years, its residents have made outstanding contributions to the economic and cultural life of the larger community.

For some time, I have written a newspaper column for the *Shoreline Times* that focuses on the history and features the people, places and events in Saybrook and surrounding areas. In the course of preparing these pieces, it became evident that not only were there many outstanding individuals here but also that (somewhat surprisingly) many were women who made significant contributions to society. Moreover, many were unknown or underappreciated and worthy, in my view, of greater recognition and remembrance.

How are these women connected to Saybrook, and what makes them "remarkable?"

All the women selected for this publication were born or lived a formative or meaningful part of their lives in Old Saybrook. This includes those who lived here but a few years, those who spent only their childhoods here, those who

were only seasonal residents as well as those who lived all or nearly all of their lives here. Given this admittedly loose connection, I suspect many communities could also assemble a roll of exceptional individuals, but Saybrook seems to be especially blessed in having many women who excelled in both the variety of their endeavors and the social value of their accomplishments.

Included in this listing is one of the early English colonial settlers, the founder of a women's college, a wife who supported her navy husband, an accomplished but unrecognized early novelist, a fighter for women's divorce rights, a missionary who became an early physician and psychologist, a beloved educator who is memorialized at the U.S. Capitol, an advocate for women's suffrage and birth control, the first female druggist in Connecticut, a prominent best-selling African American author, a universally recognized actress, an admired school administrator, young women who sent hometown news to World War II service people, a successful businesswoman, an author and historian, a public-spirited public official and a community-minded women's group.

Given more time and resources, there are other deserving women in Old Saybrook history that might have been included. One of these would be Janet McCurdy, who came from a prominent Lyme family, was courted by Noah Webster, ultimately married Captain Elisha Hart and remains best known as the mother of seven beautiful Hart daughters.

Another would be Catherine Whittlesey, who became lighthouse keeper after her husband's death and held that difficult job from 1841 to 1850.

And then there is Harriet Chapman Chesebrough, who quietly kept a journal about a wide variety of topics at a time when it was considered men's work. Upon her death in 1897, her husband donated her two-volume manuscript to the local library. Fortunately, her manuscript was discovered and published as part of Saybrook's 350th anniversary celebration in 1984 under the title "Glimpses of Saybrook in Colonial Days."

We know little more than the names of many who were slaves, including Leah Latham "Hart," a slave for the Hart family who helped Elizabeth Hart recover when she had a premature baby in Chile. Similarly, we know little of Phyllis, a slave in the family of Samuel Hart who was purchased at the slave auction that was periodically held at the corner of Boston Post Road and Main Street next to the Humphrey Pratt Tavern.

There is also Susan Hotchkiss, daughter of Reverend Frederick and Amelia Hotchkiss, who was a founder of the Ladies Circulating Library in 1854. Susan became the first librarian, and the books were kept in the Hotchkiss home prior to the establishment of a more formal library.

Women have historically been restricted to domestic duties, and their involvement in public affairs has been discouraged or prohibited. As a result, many deserving of attention have often been left out of recorded history. In many cases, we do not know their names or circumstances. If we are fortunate, the details of their lives are discovered through genealogy and become the province of family history.

The women included in this book faced restricted social, cultural and political rights and rejected those limits. Some were pioneers in their fields, and many confronted and overcame prejudices. They broke commonly accepted barriers and were resolute and determined leaders. By choosing and often struggling for a purposeful life, they expanded the opportunities for themselves and other women and made lasting contributions to the larger society.

If their lives exemplify lessons to be learned, it may be that effort and intelligence are essential for achieving goals, that individual values shape decisions and that perseverance overcomes obstacles. These women faced challenges and unlocked opportunities as a result of a solid but often quiet confidence in their own ideas and abilities. Each led an inspirational life that exemplified characteristics of strength and determination and exhibited a belief in the worthiness of humanity. In each of these lives are lessons for all of us.

Ultimately, these women are important and inspirational because their lives made a beneficial difference in the lives of others. That potential rests within all of us. These stories are "starters" that we hope will motivate and inspire younger readers to use their lives to make worthwhile contributions for the benefit of others.

Tedd Levy
December 17, 2012

THE LEGEND OF RED BIRD

There's an old Saybrook legend about a beautiful Indian girl who was attracted to a young colonist who returned her affection. The girl's father opposed the relationship and made a dramatic sacrifice on a large sloping rock called Obed's Altar. Several of the individuals in the story actually existed.

The time is the mid-1600s, and our setting is a short distance north of the village of Saybrook on the hills overlooking the Connecticut River. Here lived Obed, the son of a Hammonasset chief. Obed hunted and fished and offered sacrifices to the Great Spirit on a large sloping rock near his wigwam. The area was known as Obed's Hummock or Obed's Heights, and the table-like rock was Obed's Altar.

When Obed was about forty years old, the new minister in Saybrook, Reverend Thomas Buckingham, befriended him. The two men owned land near each other and often talked. A strong bond developed between them, and Obed often sent the minister deer and other game from his hunts.

Obed's daughter, Red Bird, was the last of his royal family. Her association with young women in the village and instruction from Reverend Buckingham led her to convert to Christianity. She was baptized and given the name of Adina and provided with a seat in the minister's pew in the meetinghouse.

Even though Obed was not happy that she had forsaken her ancestors, he was very fond of Red Bird, and the two lived contentedly together. As time went by, a young man from the east side of the river fell in love with

Red Bird, and she returned his love. Some say his name was Arthur Hart, but there is little certainty about this. This was too much for Obed, who refused to give his daughter in marriage to the Englishman and was unable to convince Red Bird to stop seeing the settler. It was difficult for Red Bird to disobey her father. He had always been kind to her, and she had great affection for him. But youthful passion being more intense than a father's wishes, she planned to run off with her young lover.

On a rainy and windy night, Red Bird slipped quietly out to meet her lover on the bank of the long river. Here they boarded a little boat and rowed away from shore. The wind was powerful, and the rain was heavy—the storm grew more violent. The raging river quickly swept their little boat downstream and into Long Island Sound. It was no match for the storm. They were never heard from again. The beautiful daughter of the Indian chief and her lover were gone. Only the wreck of their little boat was found.

When Obed learned of the loss of his daughter, he was filled with sorrow and regret for the way he had treated her. He felt that he must make amends by offering a daily sacrifice. Selecting a large flat rock for his altar, he brought some of the results of his hunting or trapping to offer to the Great Spirit. Each day, townspeople would see smoke rising from Obed's Altar. They knew he was trying to obtain forgiveness.

Reverend Buckingham talked with Obed and tried to change his sacrificial practices and inspire him with higher hopes for eternal life. One day, the minister said, he might have the protection of the white man's God. On the next morning, the townspeople did not see smoke; there was no fire on Obed's altar. Instead, they found the lifeless body of the sorrowful Indian lying upon the rock.

You may doubt this legend of forbidden love, but it has been told for more than two hundred years. There are some variations, most of which state that Obed was too fond of "firewater," which caused him to act like a demon, but most stories are very similar. There have been other similar legends that tell of forbidden and tragic love affairs between a young Indian maiden, often a princess, and a European settler. Young lovers of different backgrounds disobey and plunge to their deaths off rocky ledges, drown in turbulent waters or face other terrible ends. The stories speak to the spirit of youthful rebellion against social restrictions, family hierarchy, relations between cultural groups, prejudices and other social and political issues. Typically, they end in death or disappearance, and the spirit of the lovers or the anger of natural forces return each year as a symbolic reminder of the legend.

The redbird, or cardinal, has often been used to represent blood, energy or a "life force," luck or hope. It is often associated with Christmas and used in designs and decorations. Moreover, there are folk tales of cardinals appearing in dreams just before or after death. Red Bird is featured as either a name or an actual bird in both Native American and colonial tales.

In this story, both Obed and Reverend Thomas Buckingham actually existed. Years before the hills along the Connecticut River became a developer's delight, photos were taken of Obed's Altar. But today, no one seems to know where it was located. A changing landscape and new developments may have resulted in its being buried or broken, but the story lives on.

Obed's tale was told many years ago, and even now, when the autumn tempests howl at night around Saybrook Point, the faint cries of the lovers can be heard in the sound of the sea birds.

Chapter 2

LADY FENWICK

The Day They Buried the Lady—Again

For 225 years, one grave remained alone and undisturbed inside the fort at Saybrook Point. Here beneath a curved Portland brownstone resting on three short pillars was the tombstone of Lady Fenwick, wife of the first governor of Saybrook Colony. Here where the earliest settlers had lived was the marker for the bright and charming woman who had come with her husband in the earliest days of settlement. But she now lay in the way of progress. That "progress" came in the form of the railroad, which in 1870 demanded, as the *New York Times* reported, "the exact site of the grave for a roundhouse or some other such abomination of modern transportation facilities."

George Fenwick had come a second time to Saybrook in July 1639 with his new wife, the Lady Alice, daughter of Sir Edward Apsley and the widow of John Boteler. She was by courtesy called Lady Boteler, and after coming to Saybrook was known as Lady Fenwick. She is described as tall, graceful and cheerful, with auburn hair. She cultivated flowers, fruits and herbs; kept pet rabbits; and enjoyed riding horseback or practicing with her "shooting iron." Over the next few years, she would give birth to two daughters, Elizabeth and Dorothy. Most accounts indicate that the birth of Dorothy in 1645 led to her untimely death.

After the death of his wife, George Fenwick, leader of the little colony, returned to England with his young children and their nurse, Dame Eleanor Selby. In 1652, Fenwick married his second wife, Katharine, a niece of Robert Lord Brooke, one of the original patentees of Saybrook colony. Prior

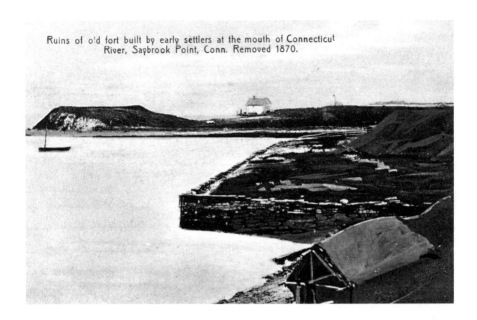

Ruins of old fort built by early settlers at the mouth of Connecticut River, Saybrook Point, Conn. Removed 1870.

This early 1900s postcard shows the site of the second Saybrook Fort near the original settlement. With threats from the Dutch and Indian tribes, Saybrook Colony governor John Winthrop Jr. appointed soldier and engineer Lion Gardiner to build the fort and lay out a town. George Fenwick and Lady Fenwick were the only English patentees to come to the colony. After Lady Fenwick died, she was buried here, and the site was marked by a tombstone brought from Portland. The gravesite remained here for more than two hundred years until it was moved to Cypress Cemetery. *Author's collection.*

to returning to England, Governor Fenwick had made arrangements with Matthew Griswold and his heirs to care for his wife's (thought to be) final resting place in exchange for several hundred acres in Black Hall on the eastern side of the river. Then "progress" struck.

On the morning of November 18, 1870, fifteen or twenty people gathered at the grave to witness the removal of the remains, if any, of Lady Fenwick. Many were doubtful of finding anything. The digging progressed slowly, and the crowed was heartened when they came to some black earth. Then they saw a bone—then a few pieces of the coffin. Finally, they came upon the remaining bones, all of which were in a reportedly remarkable state of preservation, and a few braids of auburn hair. The bones were placed in a box and brought to the house of William J. Clark, where anyone who wished could see the remains.

Funeral services were held on November 23, 1870, at the Congregational Church with the Reverend S. McCall occupying the pulpit. The solemn

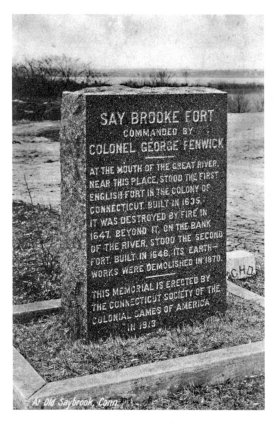

SAY BROOKE FORT
COMMANDED BY
COLONEL GEORGE FENWICK

AT THE MOUTH OF THE GREAT RIVER,
NEAR THIS PLACE, STOOD THE FIRST
ENGLISH FORT IN THE COLONY OF
CONNECTICUT. BUILT IN 1635.
IT WAS DESTROYED BY FIRE IN
1647. BEYOND IT, ON THE BANK
OF THE RIVER, STOOD THE SECOND
FORT. BUILT IN 1648. ITS EARTH-
WORKS WERE DEMOLISHED IN 1870.

THIS MEMORIAL IS ERECTED BY
THE CONNECTICUT SOCIETY OF THE
COLONIAL DAMES OF AMERICA
IN 1913.

At Old Saybrook, Conn.

George Fenwick took over as governor and later sold the land to the Connecticut Colony. The original area included today's towns of Chester, Deep River, Essex, Lyme, Old Lyme and Westbrook as well as Old Saybrook. Fenwick turned over the seal of the colony, which depicted fifteen vines bearing fruit. This symbol was modified to show three vines and is today the official state seal and centerpiece of the Connecticut state flag. *Author's collection.*

bells tolled. A train—the perpetrator of this disruptive event—had brought three hundred strangers to town. Lady Fenwick was the first woman for whom a tombstone was erected in Connecticut. Her remains were re-interred in Cypress Cemetery on November 23, 1870. The new burial site is marked by the original monument commissioned in 1679 by Benjamin Batten, the son-in-law of Mr. Fenwick's sister.

Reverend Shepard's reading of the ninetieth psalm was followed by Reverend Chesebrough, who offered a prayer. The choir sang, and then Reverend Heald provided some history about the Lady, saying that she was born about 1612 or 1613. Yale professor Gilman then gave what was called "a smooth flowing speech," commenting on places connected to Saybrook, mostly Yale College. Ralph Smith, of Guilford, provided additional facts about Lady Fenwick's life and family.

Then it was time for Dr. Grannis, who had examined the bones, to give his report. He said he had carefully examined the bones and concluded that they were the skeleton of a white female between the ages of thirty and sixty and that at the time of death there was a decided curvature of the spine.

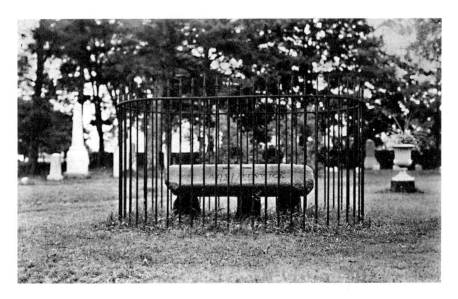

Lady Fenwick's burial site at Cypress Cemetery, where she was re-interred. Lady Fenwick was reportedly a person of "great cheerfulness" who cultivated flowers, fruits and herbs for medicinal purposes; kept pet rabbits; and had a "shooting gun" of her own. *Author's collection.*

Reverend Samuel Hart read a poem by Miss Frances M. Caulkins titled "The Tomb of Lady Fenwick," which was followed by a hymn from the choir. People then passed her new black-lined coffin to gaze at the bones, which had been arranged as nearly as possible in their proper places.

Pallbearers Samuel Lord, Robert Chapman, Edward Blague and George Denison placed her in the hearse, which then moved slowly and was followed by the uniformed pupils of the Seabury Institute, bearing their guns reversed. They were followed by a procession of about eighteen or twenty carriages and a large number on foot despite the fact that it was a cold, blustering day.

The Reverend Mr. Heald of the Episcopal Church conducted the funeral service, after which the assembled mourners recited the Lord's Prayer. The Lady had her new resting place. And today, ironically, near the site of her original grave, are the remains of the train.

According to William Tully in his *History of Middlesex County*, Jeannette Hart arranged and paid for the inscription on the tomb of Lady Fenwick. To the dismay of the descendants of Saybrook Puritans, she had a large cross engraved on the tomb—along with an incorrect date of death. The tomb reads 1648, but historians date her death to 1645 or 1646. To her credit,

Miss Hart also provided the iron fence that fronts the cemetery and remains to this day.

Early historic documents note that in return for being granted Black Hall Estate across the Connecticut River in what is now Old Lyme, original settler Matthew Griswold and his descendants were "obliged to keep [Lady Fenwick's tomb] in repair and considern [sic] of Black Hall Estate." This was apparently done in the early days until discontinued and followed by a long period of neglect. After this interlude of care, tenth-generation descendants of Matthew Griswold once again began fulfilling his original obligation of caring for Lady Fenwick's grave in the early 2000s by contributing to Cypress Cemetery Association.

Over the years, the soft sandstone of Lady Fenwick's monument has deteriorated and attracted a destructive moss. Restoration work was done in the 1970s, and in 2009, the tombstone was cleaned and stabilized.

The sand and gravel that made up the old Fort Hill and Lady Fenwick's original burial site were removed to make way for the railway facilities. All that remains are the last vestiges of the Connecticut Valley Railroad roundhouse and the turntable that was used to turn the steam engines around for the trip back to Saybrook Junction. The turntable was placed on the National Register of Historic Places in 1994 and today is part of a town park. The Old Saybrook Historical Society has possession of two locks of Lady Fenwick's hair.

At the re-interment service in 1870, Reverend Hart of Trinity College read a poem by Miss Frances M. Caulkins, part of which is presented here. The following stanzas were included in a musical work commissioned by the Old Saybrook High School Band (John LaDone, music director) and the Old Saybrook High School Chorus (Susan Clarke, music director) in 1998:

THE TOMB OF LADY FENWICK

On Saybrook's wave-washed height
The English lady sleeps,
Lonely the tomb, but an angel of light
The door of the sepulcher keeps.

No roof—no leafy shade
The vaulted glory mars,
She sleeps in peace, with the light on her bed
Of a thousand kindly stars.

She sleeps where oft she stood,
Far from her native shore,
Wistfully watching the bark as it rode,
To the home she should see no more.

By grateful love enshrined
In memory's book heart-bound,
She sank to rest with the cool sea wind,
And the river murmuring round.

And ever this wave-washed shore,
Shall be linked with her tomb and fame,
And blend with the wind and billowy roar,
The music of her name.

Chapter 3

EMILY INGHAM

Pioneer Educator

Without sympathy or sentiment, the old newspaper headline blared "Ingham University Closed: New York's First College for Women Sold Out Under Foreclosure." It was a report of the sale by the sheriff of Genesee County of the furniture and property that brought to a close a well-known school for young women who battled bravely but with little hope to save their alma mater.

While no one could have dreamed it possible at the time, the story begins in Saybrook on March 8, 1811, with the birth of Emily Eliza and Julia Ann, twin daughters born to Amasa and Mary Chapman Ingham, both descendants of first settlers of Saybrook.

Amasa, who ran a sawmill on Crystal Lake, and Mary had fourteen children, twelve of whom lived to maturity. However, Amasa was concerned that Mary might not live long enough to raise all the children, and he placed daughter Emily Eliza (1811–89) under the care of her twelve-year-old sister, Marietta (1797–1867).

As they grew up, the sisters became very close. Marietta was energetic, tactful and sensible and had a good business sense. Emily, with her winning personality, was scholarly and somewhat visionary. As young ladies, they agreed to enter missionary work.

In 1833, twenty-two-year-old Emily and thirty-six-year-old Marietta left Saybrook to travel west. Taking the recently opened Erie Canal to Brockport, New York, they then traveled by stagecoach to Attica. The name fascinated them, particularly Emily, who originally wanted to do her mission work in Greece.

Emily Ingham and her sister Marietta moved west into New York, where they established LeRoy Female Seminary, later Ingham University. It became New York's first college for women and provided education for eight thousand students over its half century of existence. *Courtesy of LeRoy Historical Society, LeRoy, New York.*

The sisters were well received in Attica and by 1835 were persuaded to establish a school there. They rented two rooms and began a school for girls, the Attica Seminary. Word of their success spread, and a committee from nearby LeRoy, New York, visited to offer them a two-story building on two acres if they would start a school in their town. They accepted and on May 3, 1837, opened the LeRoy Female Seminary, with forty-one pupils in the primary department. In 1841, the seminary received an official charter from the New York state legislature. The school operated on a three-term basis of fifteen weeks per term. Tuition and board was seventy-five dollars, with an additional charge for washing clothes. Emily served as principal.

Among the instructors was Phineas Staunton, an adventuresome Civil War veteran who had become an accomplished portrait painter. In 1847, he and Emily were married. They honeymooned in Europe, where he painted and she studied European education, and returned to live in a small cottage near the school. Phineas became an important member of the faculty, teaching art and languages while also serving on the board of trustees.

In the late 1840s, Emily and Marietta and the seminary staff began to develop a vision for a women's college. They were familiar with the work of Mary Lyon, who would later open the Mt. Holyoke Female Seminary and with whom Emily had studied at the Ipswich Female Seminary. Attendance increased, and in 1851, a house next door was purchased. The upstairs hall had rows of seats around the perimeter and a platform in the middle, which was used daily for calisthenics.

The following year, on April 6, the school was incorporated as the Ingham Collegiate Institute with the goal of "advancing young ladies in all the branches of a thorough and accomplished education." In 1856, school officials applied for a university charter so that the school could confer literary honors and degrees and issue diplomas. Their application was rejected by the state legislature, which believed there should be no such thing as a college for women.

A handbill promoting the school that year stated that it could accommodate 150 to 200 young ladies and that Principal Emily Ingham Staunton was "already favorably known to the pubic as eminently qualified with professional talent and experience and amply sustained with a competent body of teachers." Their vision was to fulfill the

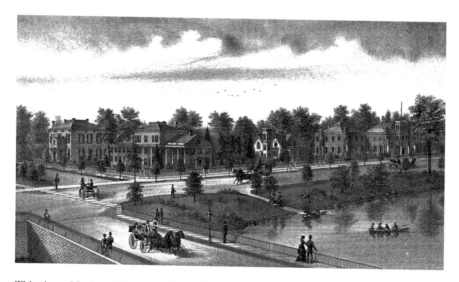

This view of Ingham University shows University Hall, Boarding Hall, the Cottage and the College of Fine Arts, none of which remain today. The brick dormitory was torn down, and the brick was used to raise the level of the west end of the Main Street bridge in LeRoy. The Cottage, which was the home of the sisters, was cut in half and moved to make two houses on a side street in LeRoy. *Courtesy of LeRoy Historical Society, LeRoy, New York.*

LeRoy Female Seminary's charter as the Ingham Collegiate Institute was obtained on April 6, 1852. The institute's full university charter was secured in 1857, making it the first female college in New York. *Courtesy of LeRoy Historical Society, LeRoy, New York.*

demand "for a permanent school of a thorough and strictly practical character" and "to render the means of education accessible to such young ladies as are desirous of them, for the sake of becoming prepared for more extended usefulness."

In the hopes of providing greater stability for the growing school, Emily Ingham turned over the entire collegiate institute to the Presbyterian Church's Synod of Genesee with the stipulation that it maintain a college program and that it establish a permanent endowment to support the school. Now under the management of the Synod of Genesee, officials returned to the state legislature and on April 28, 1857, were finally successful in gaining approval to become Ingham University. Reverend Samuel Cox became the first chancellor.

However, a number of problems were emerging that would later contribute to the school's demise. The synod seemed more interested in nearby institutions, appointed ineffective school officials and in the final

analysis was unable or unwilling to raise an endowment. The unselfish vision that was brought to upstate New York by Emily and Marietta Ingham and their supporters was not to be realized.

Emily suffered a double personal tragedy in 1867. Her sister Marietta, who had been a constant companion and effective business manager, died. In the same year, Phineas accepted an appointment as the artist for a joint Williams College-Smithsonian Institution exploration across the Andes to the mouth of the Amazon River. He became ill in Quito, Ecuador, and died, probably from yellow fever.

On December 14, 1875, Emily Ingham Staunton gave all of the property to the village of LeRoy on behalf of education. In 1883, a new charter was granted and a new board of trustees appointed. But decline became inevitable.

Having lived through the loss of her husband and her beloved sister and now broken in health and living with the disappointment that the synod had failed to secure an adequate endowment, Emily Eliza Ingham Staunton died in November 1889.

The university continued until the charter was revoked in 1892. Unable to pay the mortgages, the property was foreclosed and became the possession of banker William Lampson, who left it to Yale University upon his death. Each year, the old buildings slowly decayed. The handsome lawns became overgrown with weeds, and the gardens, fruits and flowers withered.

In 1908, the local board of education purchased the site from Yale to construct a new LeRoy High School. The entrance was framed by white roses, so loved by Emily and Marietta, and a bronze memorial was placed in their honor.

Ingham had outstanding academic credentials, was highly respected and provided quality educational offerings from a strong faculty. On the downside, it never had an adequate endowment or effective leaders other than Emily, and ultimately enrollment began to decline.

According to Richard Wing, an authority on Ingham University, without the "spirit, vision, and leadership of Emily," respectfully known as Madame Staunton, there would have been no university. Her failing health limited the leadership needed for success, and after her death in 1889, the school managed to remain open only until 1892. Wing adds:

I'm struck with a feeling of admiration and pleased astonishment at what Emily Ingham Staunton and Marietta Ingham were able to do combined

The Phineas Staunton Art Conservatory was dismantled, and the stone was used to build the Woodward Memorial Library, which today is situated next to the LeRoy Central School. Phineas Staunton, Emily's husband and an art instructor at the university, produced over 130 paintings, 2 of which can be found in the Old Saybrook Historical Society archives. One is a portrait of Amasa Ingham, Emily's father, and the other a small self-portrait. *Courtesy of LeRoy Historical Society, LeRoy, New York.*

with some sense of outrage that such an outstanding institution was so poorly served by the men who had been given the responsibility for operation and control. There also is a general sadness that such an institution did not survive. Ingham University surely deserved a better fate.

Today, according to Lynne Belluscio, curator of the LeRoy Historical Society, none of the original Ingham buildings remain. The "Cottage," which was the home of the sisters, was cut in half and moved to make two houses on a side street in LeRoy. The Phineas Staunton Art Conservatory was dismantled and its stone used to build the Woodward Memorial Library, which is situated next to the LeRoy Central School.

In 1998, North Carolina residents Steve Rodgers, a direct descendant of Amasa Ingham, and his wife, Karen, gave a portrait of Amasa to the Old

Saybrook Historical Society. The painting was done by Phineas Staunton, the art instructor at Ingham University and Emily's husband.

People depart and buildings decay, but the spirit, vision and leadership of Emily and Marietta Ingham remain as the pioneers who established the first university for women in New York.

ANN HART

A Journey Together

When the wealthy Saybrook merchant and trader Captain Elisha Hart (1758–1844) married Janet McCurdy (1765–1815) of the well-known and well-off Lyme family, he looked forward to having sons to carry on his thriving businesses, but fate and X chromosomes provided him with one daughter after another. First there was Sarah, born in 1787, then Ann (1790), Mary Ann (1792), Jeannette (1794), Elizabeth (1796), Amelia (1799) and finally Harriet Augusta in 1804—the seven beautiful Hart sisters.

The girls enjoyed the pleasant and pampered life of their prominent family. They were sent to finishing schools, including the highly respected Miss Pierce's School in Litchfield, and their exposure to the ways of the world expanded beyond small-town Saybrook. Lively, attractive, charming and sophisticated, they attracted many suitors.

While Ann Hart was attending school in Philadelphia, she and her classmates visited the ship commanded by Isaac Hull. Hull showed them about, and Ann, who was both levelheaded and adventuresome, had many questions and displayed an unusual knowledge in seafaring life gained from her father and growing up in coastal Connecticut. She commented on the neatly coiled rolls of tarred ropes and how she enjoyed the odor of tar. A few days later, she received a delicate chain made from tarred rope that was sent by Hull. She wrote thanking him for the gift and so began a correspondence that led to their marriage in 1813.

Hull, the second of, coincidentally, seven sons, was born in Derby and grew up along the shores of the Housatonic River. He developed a partiality

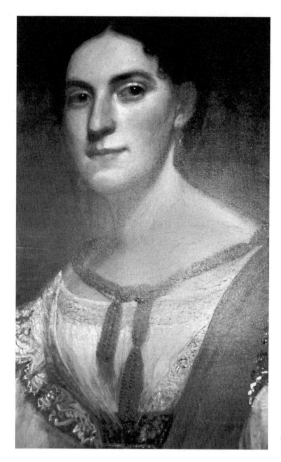

This portrait of Ann Hart, wife of Commodore Isaac Hull, hangs in the General William Hart house, home of the Old Saybrook Historical Society. Described as levelheaded, self-disciplined and adventuresome, Ann surprised many when she married Isaac, seventeen years her senior, on January 2, 1813. *Courtesy of Old Saybrook Historical Society.*

for the sea and signed on to a coastal schooner when he was fourteen. He studied navigation and by age twenty had become a master in the merchant service. In 1798, he entered the U.S. Navy.

When the War of 1812 began, thirty-nine-year-old Hull was placed in command of the frigate USS *Constitution*, named after the founding document by George Washington. Receiving orders to seek and destroy British warships between Nantucket and Halifax, he set sail. Spotting the English frigate *Guerriere* on August 19, 1812, he ordered all hands to prepare for action. When he was almost alongside the *Guerriere*, Hull gave the order: "Now boys! Pour it into them."

British shots seemed to rebound harmlessly off the *Constitution*, giving it the nickname "Old Ironsides." With heavy broadsides and his ship's superior maneuverability, Captain Hull won the day. In less than an hour, the badly

damaged British ship began to sink, and British captain James Richard Dacres was forced to surrender. It marked the first time that an English frigate surrendered to an American ship of war.

When the USS *Constitution* returned to Boston with the captured British crew, the country went wild with pride. Hull had become a national hero. He was showered with gifts, given a large sum of money for the capture and promoted to commodore.

Less than a year later, on January 2, 1813, he married Ann Hart of Saybrook, who was seventeen years his junior. From that time forward, Ann Hart Hull traveled with her husband when he went to sea. Having no intention of being left behind, Ann arranged the captain's quarters to provide accommodations for both of them. When visiting foreign ports, she often served as an official hostess. The couple had no children and were constantly accompanied by members of their families, a practice the U.S. Navy prohibited after Hull's retirement.

While the Hulls were not in the area at the time, the war came to Connecticut on April 8, 1814, when British warships arrived at Saybrook Point and moved up the Connecticut River to launch what would be the most devastating attack on American shipbuilding until Pearl Harbor. Sailing past the empty Saybrook Fort, some two hundred British soldiers surprised the residents in Potapaug (present-day Essex) and set fire to more than twenty vessels in the harbor before quickly withdrawing to Long Island Sound as area residents began to gather on both banks of the river.

In 1824, Commodore Hull was appointed commander of the Pacific squadron, and he and Ann prepared to travel to the west coast of South America. At about the same time, President James Madison appointed Heman Allen of Vermont as America's first minister to the new republic of Chile. Allen, a nephew of Vermont patriot Ethan Allen, called upon Commodore Hull to make arrangements for his passage to South America. While doing so, he met Mrs. Hull's sister Elizabeth, and in two weeks they were married. (Some time later, Isaac's nephew, Joseph Hull, met and married Ann's sister Amelia.) Soon thereafter, the Hulls and the newly married Heman and Elizabeth Hart Allen left on the frigate *United States* bound for South America.

After completing the South American assignment, Hall was given the honor of overseeing the restoration of his old ship, now commonly called "Old Ironsides." At about this time, Ann injured her foot and spent most of the next two years confined to her room. Hull resigned his command and in 1837 took her to Europe to recuperate. They spent much of their time in

Rome, where Ann's sister Sarah was living at the time. And, in an unusual twist of fate, the commodore met his old adversary, British captain James Richard Dacres, the commander of the *Guerriere*. The war behind them and having great respect for each other, they were frequently seen walking together as close companions.

In 1838, Isaac rejoined the navy but suffered strokes in 1840 and 1841 and after completing his mission returned with Ann and her sister Jeannette to settle in Philadelphia. Knowing that his end was near, Isaac made arrangements for his funeral and burial. His last words were, "I strike my flag." He died on February 13, 1843, and is buried in the Laurel Hill Cemetery in Philadelphia.

After his death, Ann and Jeannette continued to live in Philadelphia but returned each summer for a few weeks in Saybrook. They did not live in the old house but instead stayed with Captain James Rankin, a former lighthouse keeper, at his house at Saybrook Point.

Of the seven sisters, Ann Hart Hull lived the longest, and when she died in 1874, she was buried alongside Isaac in Laurel Hill. She willed the house to the town with the stipulation that it be demolished and the land used for a town park. Fearful of the expense of its upkeep, the town declined the gift, and the estate passed to the heirs, who lived elsewhere and were not interested in keeping the place. The heirs returned to put the remaining contents up for auction. The auction lasted several days and disbursed antiques, a large library, silk dresses, bonnets, china and furniture. Following the auction, the house was closed, and over time it deteriorated. It was finally torn down in 1930 to make room for the St. John's Church sanctuary. The old house was shaded by three giant elms that Elisha Hart referred to as Abraham, Isaac and Jacob. There must have been times when Elisha looked at those trees and thought they would be fine names for sons.

The *Constitution*—Old Ironsides—had become a symbol of national pride. Plans by the U.S. Navy to break it up in 1830 were met with great opposition, and the ship remained in active service until 1881. Today, Old Ironsides is based in the Boston Harbor and is designated a museum ship. It is the oldest commissioned vessel in the U.S. Navy and a popular tourist attraction. It sailed under its own power in August 2012 to commemorate the 200th anniversary of the victory over *Guerriere*.

Chapter 5

JEANNETTE HART

Romance as Fiction

by Elizabeth Kenney

Jeannette Hart (1794–1861), one of the seven beautiful daughters of Elisha and Janet McCurdy Hart of Saybrook, is best known today for a romance she never had—with Simon Bolivar, the Great Liberator of South America. Supposed to have taken place in the summer of 1826, the romance is described in detail in several books. The persistent rumor that Jeannette was betrothed to Bolivar is a complicated mystery to unravel, but historical documents disclose the actual events.

Jeannette (often spelled Jannette or Jennette when she was younger) was the fourth of the "seven graces of Saybrook," as the Hart daughters were known. In 1888, a younger cousin wrote of the sisters, whom she remembered meeting as a child, "All these daughters of Capt. Elisha Hart…were celebrated for their beauty and elegant accomplishments. They were widely known as the beautiful Miss Harts. It would be impossible, at this late date, to describe the brilliant and romantic career of these ladies… such glamour surrounds their memory."

Like many persistent historical rumors, the Hart–Bolivar romance has some basis in fact. Three of the Hart sisters did travel together to South America, and two of them likely met Bolivar. After Ann, the second-oldest sister, married Isaac Hull of Old Ironsides fame in 1813, the Hulls frequently hosted the younger Hart sisters. When Hull learned he was to be sent to South America on a diplomatic mission in 1823, he received permission to take both his wife, Ann, as well as her youngest sister, Augusta. Family letters and naval records establish that Augusta traveled with the Hulls.

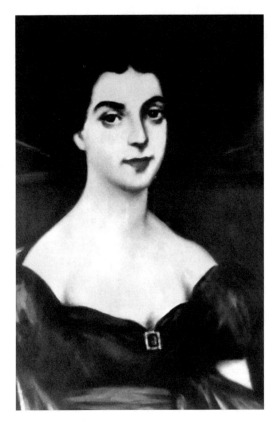

This portrait of Jeannette Hart hangs in the General William Hart house, home of the Old Saybrook Historical Society. Stories have persisted for years that Jeannette had a relationship with Simon Bolivar, the "Liberator of South America," but extensive research by Elizabeth Kenney concludes that such an affair never occurred. However, Jeannette Hart was a very early female novelist, a significant achievement. *Courtesy of Old Saybrook Historical Society.*

In addition, Hull was to take with him in the frigate *United States* Heman Allen, who was being sent by the U.S. government to Chile to serve as minister plenipotentiary. Allen came to Saybrook to meet with Hull to discuss the mission and promptly fell in love with another of the Hart sisters, Elizabeth, whom he married and took with him to Chile. At the same time that her three sisters were preparing for the voyage to South America, Jeannette Hart was in Philadelphia under the care of renowned doctor Philip Syng Physick. On Wednesday, November 26, 1823, Ann Hull wrote to another Hart sister, Sarah Jarvis, telling her of the new plan to help Jeannette regain her health:

> *Our dear Jeannette it appears is about leaving for Nassau. Capt. H., who is acquainted with the climate and the people, thinks she could not be more agreeably or favorably situated as respects her health. What a change a few short weeks has produced in our family! Is it not singular that four sisters should be embarking for distant countries at the same time?*

On December 26, 1823, Ann wrote again to Sarah about Jeannette:

> *Our dear Jeannette how far from us! Nothing consoles me for my separation from her but the hope of her restoration to health. I wrote to Dr. Post respecting her…he replied that she had no complaint which change of climate with great care would not remove. Commander Porter sails tomorrow and has promised to send one of his vessels or go himself to Nassau if he returns to the U.S. in June to offer her passage.*

So if Jeannette never went to South America and never met Bolivar, how did the rumor of their engagement arise?

The *Middlesex Gazette* on August 30, 1826, reported, "Letters have been received from Lima which announce that President Bolivar has entered into a marriage covenant with Miss Hart of Saybrook, Connecticut, sister of the lady of Commodore Hull of the frigate *United States*." The news then went viral in other newspapers, which at that time picked up and reprinted (often verbatim) items from other papers.

A few days later, the *Salem Gazette* identified the sister who traveled with Hull as "Miss Augusta Hart," and the *Richmond Enquirer* added, "Miss Hart is one of seven sisters, all beautiful and accomplished. If this be true, it is the greatest match ever known in this or that country." The *Rhode Island Republican* relayed the news in a pun: "Bolivar, the Deliverer of the South, is about to become the captive of an American Hart."

The betrothal continued to be reported in papers from Vermont to New Orleans, but on September 9, 1826, the *Connecticut Gazette* announced, "It is said the family of Miss Hart deny any knowledge of a match between her and Bolivar. The story continues to travel and passes better than any other recent hoax." The *Providence Journal* reported that the family distinctly denied the report, adding, "The person who first stated this story…deserves execration," and in November, the *Vermont Gazette* regretfully stated that a gentleman recently arrived from Peru who was acquainted with both parties reported that such an event was not even hinted at. After this, the rumor of a Hart sister romance with Bolivar died out—until it was revived about one hundred years later in the 1942 historical romance novel written by Connecticut author Marguerite Allis.

Allis made Jeannette the central character in her novel *The Splendor Stays: An Historical Novel Based on the Lives of the Seven Hart Sisters of Saybrook, Connecticut,* sending Jeannette to South America with the Hulls instead of Augusta. In the novel, the plucky Yankee becomes attracted to the powerful liberator, but a

misunderstanding breaks off the romance. Perhaps Allis focused on Jeannette because family memoirs and contemporary letters represent Jeannette as the most glamorous of the sisters. Augusta, the youngest, was commonly dismissed as unequal to her older sisters, while Jeannette's beauty and wit were widely celebrated. A niece who had known the sisters in her youth recalled:

> *Of the seven sisters of this family, Miss Augusta was not remarkable in face, though she had a very fine figure. But between Mrs. Jarvis, Mrs. Isaac Hull, Miss Mary Ann, Miss Jeannette and Mrs. Allen, it was difficult to decide which was the most perfect in the chiseling of her features, the exquisite coloring, clearness and fairness of her complexion, the richness of her brown curling hair, the soft brilliancy of her large dark eyes, and—rarer still—in the elegance of her whole person.*

Based on Allis's work, several other writers have written about a romance between Jeannette and Bolivar as if it were historical fact, including Antonio Maya in *Jeannette Hart, La Novia Norteamericana de Simon Bolivar* (1974). This book, which presents itself as an accurate history, is illustrated by the line drawings from the Allis novel.

In 1981, Marion Hepburn Grant published *The Hart Dynasty of Saybrook*, a historical genealogical account of the Hart family. Treating Allis's fictional account as if it were a reliable source, Grant tells the same story of a passionate romance between Jeannette and Bolivar. She repeats the same letter from Bolivar to Jeannette that appears in the Allis novel. In the novel, Jeannette receives a letter from Bolivar stating that he has learned the real story behind the misunderstanding that separated them, telling her, "Perhaps too, you will not believe that, as you have been the finest woman in my life, so too, you are the last one. Henceforth I devote myself to no woman other than my motherland!"

In reality, Jeannette Hart was a remarkable woman in her own right. She deserves to be known for what she did accomplish rather than a romance she never had. In the same year that Allis's novel was published, another work of fiction was reissued. *Letters From the Bahama Islands, Written in 1823–1824*, had been first published anonymously in 1827. The heroine of Allis's fictionalized history, Jeannette, had actually been the author of the latter and was one of the earliest American woman writers of literary fiction, though she is unrecognized today.

Although she did not have a romance with Bolivar and was never married, both Jeannette's beauty and accomplishments were widely celebrated. For example, in a letter to Isaac Hull on February 5, 1828, John R. Fenwick

expresses worry about the health of his "interesting and charming friend Miss Jeannette," hoping that she will "regain those physical powers which are to give to society, that animation, those charms [and] fascinating endearments which her accomplishment of mind and talent so eminently enable her to contribute to!" A family history published in the 1880s hints at a more serious though unnamed admirer:

> *While Com. Isaac Hull was the head of the Navy Yard at Charlestown, Mass., their home was the centre of a charming social circle from Boston, including some of our best artists, attracted by the beautiful women of the family. There is a tradition that* [Jeannette] *became engaged to a young artist, who afterwards, in another field, became one of the most distinguished men our country has produced.*

Morse family papers reveal that the distinguished man was Samuel F.B. Morse, best known as the inventor of the Morse code and the telegraph but then considered a promising American painter.

On February 8, 1815, Morse wrote from London, where he was studying painting, to Jeannette's brother-in-law, Reverend Samuel Jarvis, "With respect to what you say of the amiable Jeannette, the ardency of my affection for her remains unabated." However, Morse returned later that year and on November 10 wrote the following:

> *It is decided forever. Jannette and I can never be united. She will always command my esteem not a little increased by the goodness and candour with which she undeceived me; not waiting until my affections should have been more dangerously riveted, and thus sparing my feelings…now my aim shall be to add my mite to her rising glory.*

Jeannette was celebrated by others as well for her combination of beauty and intelligence. In Reverend Horace Holley's poem "Lines Addressed to Miss Jennette Hart of Saybrook," the fourth stanza reads:

> *But her bright form a brighter soul*
> *With feelings warm and taste refin'd*
> *When her dark eyes of beauty roll*
> *Their radiance is the light of mind*
> *And thus those eyes are speaking yet*
> *To him whose heart responds Jennette.*

Jeannette Hart was not only unusually beautiful but also unusually well educated for the time, and her wide reading and intellectual interests show in her fictions. The Hart family valued education for women at a time when it was still considered a novelty. Her uncle, Reverend Frederick William Hotchkiss, a congregational minister who prepared young men to attend Yale, also instructed the young Hart sisters, who later attended the new boarding schools for women that had sprung up after the Revolutionary War. Jeannette's writing reveals a sophisticated knowledge of classical, European and American writers, as well as fluency in Italian.

Jeannette, who was one of only about ten American women who published literary fiction in the 1820s, published her works anonymously. Her authorship, however, was an open secret among family members and acquaintances, and considerable evidence remains, including correspondence with friends and family, extant works with handwritten attributions and mention in early bibliographies of American authors. Over time, however, the connection between Jeannette and her books became obscured, in part because of changing literary taste and neglect.

Jeannette published three works of fiction: *Nahant: Or "The Floure of Souvenance"* (1827) and *Letters from the Bahama Islands, Written in 1823–1824* (1827), both published by H.C. Carey and Lea of Philadelphia, and *Cora: Or the Genius of America* (1828), published by E. Littell, also of Philadelphia. All three works share an unusual set of characteristics. They all include elements of travel literature, drawing on her trips to the island of Nahant and to the Bahamas, and they all employ a story-within-a-story structure and a first-person narrator. All three also combine a realistic, contemporary setting with romantic fanciful elements. Thematically, the works contrast the sublime natural world and the artificial social world; contain tragic stories of passionate love ending in death; and compare American and European literature, art, politics and society. The difficulty of categorizing these complex works has contributed to their lack of literary success.

Jeannette would have visited Nahant, which was becoming a fashionable seaside tourist spot, in 1819 when she was staying with the Hulls in Boston. The novel *Nahant* tells a story in which an unnamed narrator rides to Nahant from Boston and there observes two young lovers by the ocean. The young man, who is soon to sail to Europe to ask his parents' permission to marry his beloved Alice, rows a small dingy to a rock on which the "floure of souvenance" (forget-me-not) grows, believing a legend that the girl who receives that flower from the hand of her lover will always be faithful. But

a storm arises, and as he drowns, he flings the flower to Alice, crying as the waves close over his head, "Forget me not!"

On December 6, 1827, Ann F. Humphreys of Boston wrote to Jeannette's sister Sarah, "Your sister's little book is [a] very pleasing and elegant little production, but in Boston it has no success among the Blues [and] they of course must decide on literary merit." However, Jeannette had created a local legend for the island of Nahant, much like the more famous author and family friend Washington Irving did for upstate New York in his "The Legend of Sleepy Hollow." Jeannette's legend appears in later tour guides, local histories and collections of legends and folk tales as if it were truth and not a literary construction.

In *Letters from the Bahama Islands*, Jeannette's imagination brings together European, American and Bahamian influences through an American narrator with an English mother, a French father and a mysterious Bahamian beloved whose letters describe exotic botany, extreme weather and European, "native" and slave cultures. They also recount the tragic love story of the narrator's mother, who was rejected by an insanely jealous husband. Due to the accuracy and vividness of her description of the Bahamas, the book is used as a source of historical information about the islands and appears on syllabi for courses on the Bahamas, although it is attributed simply to "Miss Hart."

In 1827, the year *Letters* was published, Jeannette wrote to her brother-in-law Samuel Jarvis:

> *You will not perchance be surprised to hear that I have placed the manuscript of the "Letters" in the hands of Mr. Carey and Lea. They offer me no inducement to publish, but I have determined to, and I am told by Mr. Carey that if the Literary Hercules of the city does not kill me, that I may live, and perhaps succeed.*

Letters did get a comparatively lengthy review in the *United States Review and Literary Gazette* (Vol. II, 1827), which concluded, "This book is not, as one might from its title be led to imagine, a mere account of the Islands from which the letters purport to be written. It aims at something more, at mingling the incidents of a fictitious tale with the description of the country and its inhabitants."

The cousin who recorded the family stories of the Hart sisters recalled of Jeannette that "Miss Hart wrote two or three very imaginative books in the stately, high-flown style of the period, one entitled *Cora, or the Genius of*

America." In this work, the narrator meets Cora, who is visiting the United States from a tropical island, in the midst of a glittering social scene, and each woman perceives a depth of thoughtfulness in the other that leads them to become friends. In the first half of the story, the two discuss literature and politics, striving to define the uniquely American spirit, or "genius" that distinguishes it from contemporary Europe and ancient Rome and Greece. One day, Cora reveals her own complicated story. She tells of being raised on the tropical island, which became her permanent home when her parents returned to France and became victims of the French Revolution. Their dying wish was that she would marry a particular man whom she respected but did not love, and, in fact, a mysterious stranger does arouse her passion. After marrying as they wished, she quickly dies of suppressed grief.

Jeannette sent her uncle Reverend Hotchkiss a copy of *Cora*, writing, "Perhaps you may be pleased to trace the development of the mind which your instructions assisted in forming, but you will find it like a garden overrun with weeds, and I feel deeply the truth of this confession." On the back of her letter, Hotchkiss jotted some notes to himself before composing his response:

> *I thank you, my dear cousin, for* [the] *privilege of reading "The Genius of America." In* [the] *little volume I see evidence of talent, a cultivated mind, a discriminating taste, vivid imagination and glowing description. It is the privilege of Genius, like* [the] *sun, to emit beauty and splendor on every object which it irradiates, and what we admire, we love and imitate.*

In addition to publishing three works of fiction at a time when very few women published, Jeannette also converted to Catholicism at a time of intense anti-Catholic sentiment. In 1832, on a visit to Washington, she met the charismatic priest Charles Constantine Pise, chaplain to the U.S. Senate, and converted. At about this same time, an anti-Catholic mob burned down the Ursuline convent in Charlestown, Massachusetts, not far from where she had stayed with her brother-in-law Isaac Hull. Jeannette's sister Ann wrote to Sarah Jarvis about their sister's conversion, "She has decided as you know. Hers is no common mind, and she has made it a matter of long consideration and inquiry."

Jeannette supported her sister Sarah through a very public divorce, writing to her in 1839:

The very word divorce seems to fill the minds of those with whom I talk with horror. It seems to me a pity that such a great degree of notoriety should be attached to the case through the gallantry of newspaper editors, but if it is necessary to success, I do not know why we should care.

As a cousin said of the sisters in writing the family memoirs, "Such a glamour surrounds their memory that it is difficult to see them clearly, and still more difficult to depict them. Because they were so famous in their generation, we give such pictures of them as we can." In Jeanette's case, seeing her more clearly will also help to understand the early development of American women's fiction writing.

THE MINISTER'S MARRIAGE
Forgive Us Our Trespasses

Their marriage had all the appearances of an arrangement made in heaven. He was the wealthy son of the second Episcopal bishop of Connecticut, a graduate of Yale and an ordained and scholarly minister. She was the beautiful and spirited oldest daughter of Elisha Hart, a prominent Saybrook merchant. And on a warm summer day in July 1810, Reverend Samuel F. Jarvis (1786–1851) married Miss Sarah McCurdy Hart (1787–1863) at St. Michael's Church in Bloomingdale, New York, his first parish.

But, as sometimes happens, this was a mismatch that was made far from heaven. Samuel has been described as serious, humorless, proud and extremely stubborn, while Sarah was considered high-strung and quick tempered. They soon annoyed, angered and infuriated each other.

Once, when Samuel told Sarah he would be having a few ministers over for tea, he asked her to serve a "light supper." A few evenings later, when they were invited into the dining room, there was nothing on the table but lighted candles. Not funny.

On one occasion, Sarah reported that Samuel punched her several times on the side of her head and that her pain required the attention of a doctor. She was confined to her room for more than a week, during which time her husband never spoke to her.

Another time, her daughter spilled a drop of ink on her book, and Dr. Jarvis grabbed the book and struck the child in the face. Sarah protested the harsh punishment. He then "seized her by the nose and held and

wrung that with one hand, while with the other he beat her violently on the side of the head."

The physical abuse was not all. A "German female" was employed in the family as governess, and Sarah claimed that Dr. Jarvis showed her "a very improper partiality" and bestowed upon her "those civilities which belong only to a wife." His devotion to another, Sarah said, was "calculated to render [his] wife broken hearted."

For her part, Sarah was unwilling to take on the role of a typical minister's wife, causing some to question his career. After six years at St. Paul's Church in Boston, Samuel moved his family to Italy. Marital life was no better with the change of scenery, and Samuel pursued few pastoral duties. Along with drinking half a gallon of sherry each day, he spent most of his time studying, writing and collecting books for his library.

For Sarah, the excitement of life in Italy and the preoccupation of her husband were liberating and exhilarating—but not always.

After a quarrel one night in Sienna, Dr. Jarvis had the cook drag Sarah to her room. Her son sprang to her defense but was quickly subdued by Dr. Jarvis and locked outside in the snow. Terrorized, Sarah sunk beneath a table, and when her husband and the cook returned, they each grasped one arm and forcibly dragged her along the floor through the house until they reached her room. There she remained sobbing. About midnight, some three hours later, her husband sent her a message stating that unless she stopped crying her son would not be admitted into the house. A short time later, when she was able to control her sobbing, her son was finally allowed back into the house. After this, her husband ordered her to keep her own apartment and locked her out of the rooms occupied by himself and the rest of the family.

All hope for saving their marriage ended when Sarah decided to become a Roman Catholic.

Samuel returned to Connecticut in 1835, leaving his wife and children in Europe and explaining that the children's health and education required them to stay. He became rector of Christ Church in Middletown, where he began renovating a hotel to house his library and art collection.

Sarah returned one year later, having had to borrow money from her father for the journey. When she and the children arrived, Samuel sent them to live with a cousin. Shocked by the reception, Sarah was advised by friends and family to negotiate a separate maintenance allowance, a typical arrangement at that time for incompatible couples in their social sphere. Samuel refused the arrangement and wrote to a medical friend at the Hartford Retreat for the Insane, "It appears to me therefore that I have only

one alternative, either to place her at once under your care or…to threaten her with such a course and endeavor to frighten her into submission."

Friends of Dr. Jarvis advised him to establish a separate living arrangement for Mrs. Jarvis, but he refused. Therefore, in January 1839, she took the uncommon step of seeking a divorce. Following the procedures, she filed a petition with the Connecticut State Legislature. Her case would be heard and decided by a divorce committee. Her petition stated that since her marriage, her life had been "one continued scene of wretchedness" and that her husband "had a disposition wholly incompatible with domestic happiness. His spirit was tyrannical, and his temper towards your petitioner violent, reckless, and ungovernable." She alleged that he had "inflicted cruel blows" while she attempted to keep her misery to herself to preserve the reputation of the family, claiming:

> *These attacks upon her person, her character, and her peace have reduced her to a state of wretchedness which can be endured no longer. He has accused her with being insane and has kept a separate sleeping apartment for many years. He refuses to speak to her except when company is present or to reprimand her. And while he may be worth more than one hundred thousand dollars, he refuses to provide her with food except for what is placed at the table where she is permitted to sit in silence.*

Elisha Hart, Sarah's father, testified in a deposition to the legislature:

> *Until her unhappy marriage with Dr. Jarvis, I always found her a most kind, affectionate and obedient child, frugal in her expenses and exemplary in all her ways. As a mother, no one could have been more affectionate or devoted to her children, and in all the relations of married life, she was peculiarly fitted to fulfill the duties of her station.*

Samuel vigorously contested the divorce and retained several noted attorneys: Nathaniel Terry, Thaddeus Betts, Calvin Goddard, R.I. Ingersoll and Joshua S. Ferris. Sarah and her family hired their own set of notable attorneys, among them Roger S. Baldwin, grandson of the signer of the Declaration of Independence and defender of the Amistad Africans. Others included Roger M. Sherman, W. Hungerford, C.C. Tyler and cousin C.J. McCurdy.

Well-known members of both families testified, and although some members of the legislative committee found Samuel's behavior inexcusable,

they did not think it grounds for divorce. When Sarah's petition for divorce was vetoed by Governor William W. Ellsworth, a close friend of Samuel's, Sarah's sister Jeannette wrote in defense of her sister in her fable *The Owl and the Dove*:

> *The dove, after being despoiled by the owl of her beautiful plumage, was suffered to return to the dovecote of her parents to ponder over her past life and regret having been persuaded contrary to her own judgment to give herself to one incapable of appreciating her merits or comprehending her character.*

The moral of this fable: "A gentle and docile nature might attempt to school itself into obedience and submission, yet if not met on the other side by concessions and indulgences, there can be no chance of domestic harmony."

At that time, the permissible grounds for divorce included adultery, fraudulent contract, desertion or prolonged absence with a presumption of death. In 1843, these were expanded to include habitual drunkenness and intolerable cruelty. Having lost her case but not her resolve, Sarah again petitioned the state legislature for divorce in 1842. Stubborn Samuel again mounted an aggressive defense, but this time Sarah held the upper hand. Her former counsel Roger S. Baldwin was now governor, and with friends and relatives in the legislature, she was granted a divorce and alimony of $600 a year.

Attitudes toward human rights and women's rights were also changing. Abolition and suffragette movements were underway. In the same year that she was granted her divorce, the U.S. Supreme Court heard the case of the Amistad Africans and ruled that they be freed. Soon thereafter, both female and male supporters met in Seneca Falls, New York, and in 1848 published the Declaration of Sentiments, which claimed for women "a position to which the laws of nature and God entitle them," including "the right to life, liberty, and the pursuit of happiness."

The following year, the Connecticut General Assembly passed a measure granting divorce for "any misconduct of the other party as permanently destroys the happiness of the petitioner, and defeats the purpose of the marriage relation."

Sarah's former husband predicted that she would be shamed and shunned, but that did not occur, and she remained socially active for the rest of her life.

CALISTA VINTON LUTHER

A Mission of Service

Afterserving as a Baptist missionary and teacher in Burma and raising two daughters, Calista Vinton Luther (1841–1924), age forty-one, entered the Women's Medical College of Pennsylvania to become a physician. She was a pioneer in the modern treatment of mental illness and had a summer residence and sanitarium in Saybrook, where she treated cases of what was called "nervous disease and mild insanity." In an era in which women doctors and psychiatrists were rare, she was both.

Luther's parents were both American Baptist missionaries who lived in Burma, now known as Myanmar. For thirty years, they combined preaching, working with the sick and teaching the Karen people, an ethnic group that lives in southern Burma. Calista was born in Burma in September 1841, and she and her older brother Justus were educated by their mother. Braving dangerous animals, insects and thick jungle vegetation, she and her brother traveled with their parents to visit native villages and were expected to learn their lessons on their travels as well as when they were home.

As a child, Calista assisted in caring for patients in the hospital established by her father in Rangoon. It made a lasting impression on her. When she became older, Calista learned the Karen language, wrote an algebra book in the Karen language and helped run the mission school. Meanwhile, her mother served as a teacher, met with Karen people who arrived at the mission each day, conducted prayer meetings and acted as a physician and nurse to her pupils and those in the neighborhood. In addition, she translated books

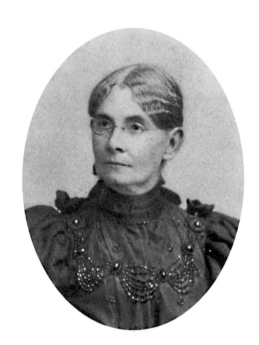

Calista Vinton Luther was a missionary to the Karen people in Burma, where she was born, and later became a physician and psychologist. Her mother frequently told her and her brother when they were children, "You must always keep in mind that you are the children of missionaries and that if you are careless of your demeanor or do any thing wrong, it will be a disgrace to the dear cause." Calista later said that this rested on her mind perhaps even more heavily than her parents intended. *Courtesy of Old Saybrook Historical Society.*

and wrote hymns, all while traveling from village to village and educating her own children.

To advance her education, Calista was sent to the United States in 1854 to attend Suffield Academy in Connecticut. For the next few years, she lived in the home of family friends Reverend and Mrs. D. Ives. While she was still in the United States, her father died in Burma.

Her mother wrote to her and her brother, "You must always keep in mind that you are the children of missionaries, and that if you are careless of your demeanor or do any thing wrong, it will be a disgrace to the dear cause." This directive was repeated so often that it became a key to Calista's sense of responsibility. She reportedly felt as if the whole cause of foreign missions rested upon her shoulders and that her conduct as a schoolgirl and example as a Christian could bring disgrace on the cause that was so important to her parents.

After returning to Burma in 1858 and entering into mission work teaching mathematics, vocal music and supervising the boarding school, both she and her mother became ill. They left Rangoon in 1862 and, after a brief stopover in England to see friends, sailed for America.

After arriving in New York, they attended a meeting of the Free Mission Society in Mount Holly, New Jersey. Here Calista met Robert Maurice

Luther (1842–1903), who had just completed his studies for the ministry at Princeton Theological Seminary but was uncertain about what he should do. She persuaded him to join the mission work with the Karen in Burma. Her mother, hoping to find someone to run the high school and take care of other educational tasks, wrote to Calista's brother about the young graduate that Calista met: "I hope the Lord will soon send him a good wife, so that they together may return with me." Little did Mrs. Vinton realize that the "good wife" would be her daughter and that the young man would soon become her son-in-law.

Calista and Robert arrived in Burma in early December 1864, at which time Calista's mother was busy building a second mission house. Regrettably, she became ill and died a few weeks after they arrived. Calista and her husband continued the work of her parents and remained at the mission until 1872, when he became ill with "jungle fever" and they were forced to return to the United States. With frequent attacks of malaria, he remained in poor health.

In 1881, Calista entered the Women's Medical College in Philadelphia, the first medical school for women and today Drexel University's College of Medicine. She graduated in 1885 to become one of only a few female physicians in the United States. Early in her practice, Calista turned to the treatment of nervous diseases and "insanity." Reform efforts succeeded in replacing "lunatic asylums" with "insane asylums," but the treatment of the mentally ill was in its very earliest crude and often cruel stages.

Calista established a "private sanitarium" in South Orange, New Jersey, and treated patients there during the winter months. In 1900, the Luthers purchased an estate in Saybrook that served as an eight-bed sanitarium in the summer. The records indicate that the estate was located on eleven acres along the highway leading to Saybrook Point. A large part of it was "planted with fruit trees and ornamental shrubbery. It is justly regarded as one of the finest places in Middlesex County."

Although many believed that treatment of insanity was hopeless, Dr. Luther believed that it was curable. Her greatest difficulty, she said, "was not from the patients but from their friends, who have been unwilling to believe that a permanent cure could be effected." She thought that the pleasant surroundings of the Saybrook sanitarium would help. "The lovely old village street with its noble elms—among the finest in New England—and the quiet beauties of the New England coast greet the eye," she reported. "Amid these beautiful surroundings, with every inducement to look away from themselves and to fix their thoughts upon external objects, the morbid

habit in the patient soon gives place to a more healthy condition of mind and recovery soon begins."

In 1900, she unsuccessfully attempted to organize New Jersey's female doctors into an association. During that same year, she reported to the Association of Medical Superintendents of American Institutions for the Insane on conditions of female doctors in the field, "The women did not stay long [in psychiatric hospitals] because professional advancement was blocked, salaries were often lower than those of men, and women were denied authority. Many left to enter private practice."

Calista Vinton Luther died in 1924. She and Robert are buried in Cypress Cemetery. The 1925 "Proceedings of the Connecticut State Medical Society" reported:

> *She was a pioneer in the modern treatment of nervous and mental diseases, and realizing that neurasthenics need treatment away from their homes, she bought an estate in Saybrook and fitted it as a sanitarium, where she was most successful in treating the many cases of nervous disease and mild insanity [that] were sent to her.*

In 1917, she became an invalid and had to give up her work while her daughter Edith cared for her. The state medical society concluded:

> *She then offered the use of her estate to the government for the care of invalid soldiers. Later she became helpless and dependent upon her daughters, until her death released her. She was a devout Christian, a most careful student and physician, gentle, generous, cordial to all with whom she came in contact; a high type of medical woman and a colleague of whom the profession is proud.*

Her mother, too, would have been justifiably proud. Her life of service was not "a disgrace to the dear cause."

MARIA SANFORD

Saybrook's Minnesota Connection

W hen a frail little old lady came forward to speak at the 1920 convention of the Daughters of the American Revolution (DAR) in Washington, D.C., many in the vast audience resigned themselves to the likelihood of not being able to hear and perhaps were not all that interested. Looking out over the hundreds that had gathered there, the fragile woman began to speak. Her clear words caused a quickly spreading hush, and her compelling message captivated their attention. At the close of her moving address, a reporter commented that never in her years of reporting had she known as long a period of uninterrupted applause.

This delicate lady was eighty-four-year-old Maria Sanford, born in Saybrook around midnight on December 18 or 19, 1836, and one of four children of Henry and Mary Sanford. She was a dynamic, innovative and admired educator and lecturer. Often called the best-loved woman in Minnesota, Maria is honored and remembered today with a statue in the National Statuary Hall in the U.S. Capitol. Her educational influence came from her mother. "I can remember," Sanford said, "when I was not yet four years old following her about in her work, begging her to tell me more about the war."

Maria's uncle had been a colonel in the Revolutionary War and had died on a prison ship. Behind her grandfather's house was a beacon hill on which a tar barrel was kept to be set on fire when the enemy landed—a signal to another beacon hill in the distance of approaching danger.

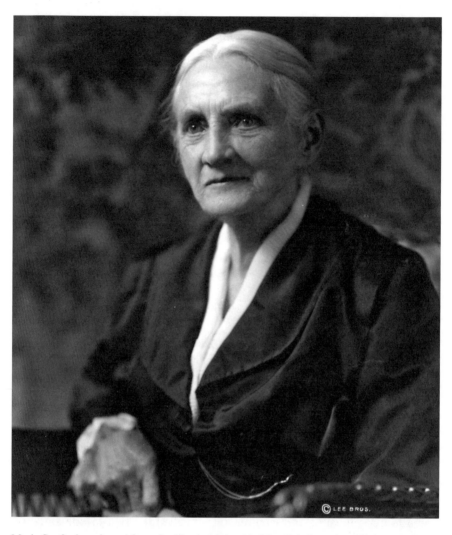

Maria Sanford graduated from the Normal School in New Britain and taught in several towns in Connecticut before becoming principal and superintendent of schools in Chester County, Pennsylvania, and serving as professor of history at Swarthmore College from 1871 to 1880. Her greatest accomplishments and fame came at the University of Minnesota, where she lectured on literature and art history. Sanford believed that the old should teach the young "the value of education not as a means to wealth but as a means to life." *Courtesy of University of Minnesota Archives, University of Minnesota–Twin Cities.*

When she was still a young child, Maria's father went to Georgia to set up a shoe shop. It worked out well until the financial panic of 1836–37 and the heightened anti-slavery "agitation" from abolitionists caused strong feelings in the South against northerners. He was forced to return home, and his family had to move into his father's house. He went to work at his brother's auger shop in Meriden. When Maria was ten years old, the family moved there. She attended the country school and by age fourteen was enrolled in the academy, walking three miles to and from the school.

Maria seemed to inherit strong mental and physical characteristics from her father and high ideals and a love of learning from her mother. She was taught that life was a precious gift to be used for something worthwhile and that to waste it was sinful.

When she saw her father give her sister Elizabeth a dowry for her marriage, she asked if she could have her dowry to attend New Britain Normal School. Her parents thought well of the idea, and she attended the Normal School, graduating with honors in 1855.

She began teaching in Hebron (then called Gilead), thinking that it was far enough away that her parents would not be embarrassed if she failed. She did well enough to be offered a contract for a second year. She went from there to teach in Glastonbury, Middlefield, Meriden and New Haven.

In New Haven, she met John Fiske, a noted historian and philosopher, who prescribed a list of historical readings for her. She resolutely worked her way through the readings and later used her knowledge as a professor of history. She also met a young theological student to whom she became engaged. Reading and discussing Darwin's *On the Origin of Species*, he began to question his religious beliefs. Maria had no such doubts and broke off the engagement. They remained in correspondence over the years, and years later, when he was sixty, he again asked her to marry him. Having perhaps less passion and definitely more obligations, she declined.

At the invitation of W.W. Woodruff, the county superintendent of schools in Pennsylvania, she accepted an offer to teach in Parkersville in 1867. In the first few months, some two hundred visitors came to see her classes. One incredulous superintendent said, "All of the pupils were doing what they wanted to, and they all wanted to do right."

With a growing reputation and the offer of a sixty-dollar salary, she left to take a position in Unionville, Pennsylvania. Although it was unusual for women to speak in public, she was invited to do so when a speaker failed to appear at the State Teachers Association meeting.

As Maria's speaking appearances increased, a board member from Swarthmore College heard her, and she was hired to fill a vacancy in the history department. She became one of the first female professors in the country in 1870. In addition to her teaching, she became widely known and in demand as a lecturer and was often the only woman to speak at teachers' institutes.

A number of factors occurred during her years at Swarthmore that culminated in her resignation after ten years. Some colleagues complained of her frequent speaking and absences from school, although the practice did not cause her to neglect her classes. Swarthmore officials conceded her right to speak but limited the number of her lectures and reduced her salary. While there do not seem to be many details, another factor may have contributed to her eventual departure. In the words of her biographer Helen Whitney, she loved and was loved in return by a married man "with whom marriage was impossible."

Her Puritan soul must have had some tortuous times, and when combined with the other issues regarding her lecturing, she resigned in 1879. That summer, Dr. William W. Folwell, first president of the University of Minnesota, came east looking for teachers. He met Maria at Chautauqua, New York, and after a half-hour conversation offered her a position to teach rhetoric and elocution. It was quite a daring move, but she headed west to join the faculty at this new university that had just one building, three hundred students and eighteen teachers.

Her amazing energy, enthusiasm and magnetic personality attracted many students. To accommodate them, she offered a class at 7:30 a.m. and took roll call each morning by having each student recite a verse of poetry. A student in her early morning class said of her, "She never seemed to tire. She was continually alert mentally and physically. Her cheerfulness never failed. Her patience seemed never exhausted. She had a keen sense of humor, which frequently tided over difficult situations. I never knew her to use an unkind or discouraging word to a student."

Similarly, she was in constant demand for lectures, sometimes speaking four or five nights a week and traveling up to one hundred miles but never missing a class. She adopted a standard dress—almost like a uniform—which she wore the rest of her life. Today, we would call it her "brand"—a plain black dress with a high neck, a black bonnet, a short black cape and a white lining at the neck. Many tried to get her to change her attire, but she thought there was grandeur in those somber black skirts when she gathered them up and sailed majestically up to her platform with her lecture notes in

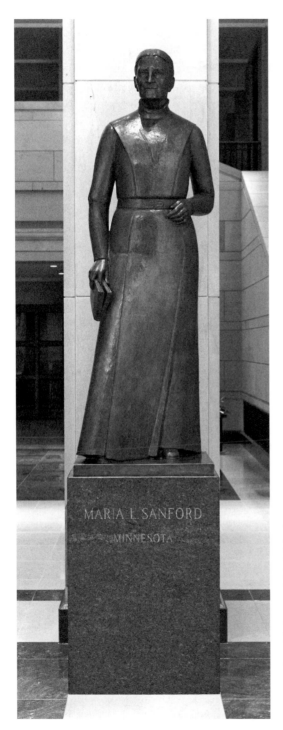

This statue of Maria Sanford was placed in the National Statuary Hall inside the United States Capitol in 1958. The governor of Minnesota proclaimed November 12, 1958, Maria L. Sanford Day and noted that she was a founder of parent-teacher groups, a pioneer in beautification and a strong voice for education for African-Americans, temperance, scholarships for the gifted, justice for Indians and women's rights. *Courtesy of Architect of the Capitol.*

her hand. "She was unflinching and energetic in all that she did," Whitney wrote, "resolute and buoyant when struck by adversity, and a lifelong believer in the homespun virtues of work well done and the meticulous payment of debts." One of those debts occurred when she invested her life savings in a real estate venture promoted by one of her students. She also got many of her friends to invest in the venture, which soon failed. Although advised to declare bankruptcy, she insisted on repaying her debts and did so by using all but thirteen dollars of her salary each month. Incredibly, it took thirty years.

During a talk in San Francisco in 1912, Maria said:

> *At seventy-five, my message to the world is: Let every human being so bear himself that the place where he stands is sacred ground. And I charge the old to teach the young the value of education, not as a means to wealth but as a means to life. If my seventy-fifth birthday were to be my last, which I hope it may not be if my strength for work is spared, I would say to my old students in whose future I still feel a strong interest, "Make the most of your lives."*

Maria Sanford was a leader in adult education, a founder of parent-teacher groups, a pioneer force in the beautification of Minnesota and a fighter for improved education for African Americans, justice for Indians and women's rights. She supported the temperance movement and traveled the country giving speeches supporting liberty bond drives for the Great War.

The day after her talk at the DAR convention, she attended a luncheon in her honor at the New Willard Hotel. She returned to the home of the senator from Minnesota, where she was staying. The following morning, she was found in bed, having died peacefully during the night.

Chapter 9

KATHARINE HOUGHTON HEPBURN

Organize, Agitate, Educate

Today it is called the Katharine Hepburn Cultural Arts Center, but it began as the Old Saybrook Musical and Dramatic Club. Its purpose was to raise funds for a new town hall by sponsoring a variety of entertainment programs. One of those theatrical performances, in particular, would have been appreciated by Katharine Hepburn. No, not the Hollywood legend but her mother.

The performance was titled "How the Vote Was Won," and there is no evidence that Katharine Houghton Hepburn (1878–1941) attended the performance, but she would have enjoyed it had she been there. The play was written by Cicely Hamilton and in 1913 had four engagements in Connecticut, including the one at the Old Saybrook Musical and Dramatic Club. Hamilton (1872–1952) was an English writer and advocate for women's rights. She coauthored "How the Vote Was Won" as a one-act comedy written specifically to support women's suffrage. It was a very popular play that ridiculed the English idea that a married woman came under the protection and authority of her husband.

In the play, the leading male argues that women do not need the vote because they are "looked after" by men. But when he is confronted with a household of female relatives demanding to be "supported," the anti-suffrage hero realizes the error of his ways and joins the march on Parliament to demand votes for women.

Cicely Hamilton supported the rights of children, widows and unmarried mothers. She advocated birth control and supported

THE
CONNECTICUT PLAYERS
IN
"HOW THE VOTE WAS WON"

AUGUST 22,

8 P. M.

TOWN HALL,

SAYBROOK.

Reserved Seats 25 Cents.

For sale at J. A. Ayres' Store

Music. Tableau.

August, 1913 — Four Engagements

| Norwalk, | - | August 8 | Saybrook, | - | August 22 |
| Pine Orchard, | | August 16 | Norwich, | - | August 29 |

Katharine Hepburn served as president of the Connecticut Woman's
Suffrage Association. As membership grew to thirty thousand, she became
disenchanted with what she saw in their passive campaigns and resigned as
president to join the more militant organization founded by Alice Paul, the
National Woman's Party. *Author's collection.*

abortion law reform. She would have enjoyed the company of a strong-minded woman from Connecticut with similar views, Katharine Houghton Hepburn.

Katharine's father was Alfred Houghton, son of Amory Houghton Sr., the founder of Corning Class Works. Alfred suffered from depression and nervous prostration from overwork and took his life when Katharine was fourteen. Katharine's mother was determined that her daughters would receive an education and be able to lead independent lives.

Katharine challenged Victorian traditions and battled with an inflexible uncle who opposed college education for women but succeeded in attending Bryn Mawr College, where she earned a degree in history and political science. Her sister Edith attended Johns Hopkins Medical School in Baltimore, and it was there that Katharine met a serious and ambitious young intern from Virginia named Tom Hepburn.

Katharine and Tom were married in 1904 and moved to the Nook Farm section of Hartford, where Tom completed his training at Hartford Hospital and began a successful medical practice. A few years later, they purchased a cottage in Fenwick, and from that point on they and their children enjoyed summers there.

The couple had six children: Thomas (1905), Katharine (1907), Richard (1911), Robert (1913), Marion (1918) and Margaret (1920). They were encouraged to excel in physical activities, to think for themselves, to speak openly about anything that prompted their interest and to stand up for what they believed.

By her own inclination and with Tom's active involvement, theirs was not a traditional Victorian family of domesticity and genteel privilege, and they became occupied with political and humanitarian causes. Tom led a campaign to eradicate venereal disease and helped establish both the American Social Hygiene Association and the Connecticut Social Hygiene Association. Both he and Katharine worked to close houses of prostitution in Hartford. They frequently hosted prominent suffragists and other activists at their home. Katharine worked for women's right to vote and organized the Hartford Political Equality League. Her causes and efforts were controversial, especially among those in her "polite" society.

In 1910, Katharine was elected president of the Connecticut Woman Suffrage Association and increased membership in the group to more than thirty thousand. However, she grew disenchanted with the passive campaigns and resigned to join a more militant national organization founded by Alice Paul, the National Woman's Party.

Katharine Hepburn co-founded the Hartford Equal Franchise League in 1913 and later became president of the Connecticut Woman Suffrage Association. She went on to join the National Woman's Party, where she served on the National Executive Committee. She worked tirelessly and made many public appearances to gain the right to vote for women. *Author's collection.*

Their efforts faced the entrenched beliefs in Connecticut of the two Republican senators who opposed a proposed amendment for woman's suffrage, and it was rejected by the General Assembly. Although Governor Marcus Holcomb was presented with a petition with over 100,000 signatures, he refused to call a special session of the General Assembly to reconsider the measure.

After a long battle that formally began in Seneca Falls, New York, in 1848, the women and their supporters finally achieved their goal in 1919 when the U.S. Congress passed the Nineteenth Amendment, stating, "The right of citizens of the United States to vote shall not be denied or abridged by the United States or by any state on account of sex." It was not until after thirty-six states approved the amendment and it went into effect that Connecticut finally ratified the amendment granting women the right to vote.

Looking back at her mother's efforts, Katharine's daughter Marion observes:

> *My mother was an ardent feminist. But she was not the kind of feminist who despised men and marriage. She simply felt that women were human beings. As human beings, they should be allowed full citizenship—such as the vote. As human beings, they should be allowed to choose their own course in life.*
>
> *Her only thesis was that choices should be made on the basis of individual taste and aptitude, not on the basis of sex or snobbery. To her, any honest job seriously undertaken was a respectable job. This attitude on Mother's part was a great relief to us who were her less talented children. My suffragette mother never felt that domesticity was beneath her. In fact, she reveled in it. But her common sense and her strong feelings for justice and democracy drove her to state quite firmly that domesticity was not an inborn interest of all women just because they were women.*

Soon after the suffrage amendment was ratified, Katharine took on another battle for women's rights and joined with Margaret Sanger, whom she knew from their childhood days in the Corning, New York area, and others to form the Connecticut Birth Control League, which later became Planned Parenthood of Connecticut.

A Connecticut law passed in 1879 but rarely enforced prohibited the use of "any drug, medicinal article or instrument for the purpose of preventing conception." Katharine strongly disapproved of the law and believed that every woman should have a choice. She urged repeal of the law and referred to it as "the police under the bed law." She argued that "women want

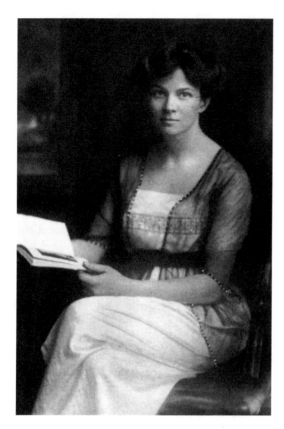

Katharine Martha Houghton Hepburn was a leader of the suffrage movement and an advocate for birth control. Working with Margaret Sanger, she co-founded the American Birth Control League, which would later become the Planned Parenthood Federation of America. *Courtesy of Katharine Houghton Grant.*

children, but they want children they can properly take care of—children that they can afford both physically and economically."

Unsuccessful in persuading the state legislature to revise the law, she joined the Connecticut Birth Control League in 1935 and opened a clinic in Hartford to distribute birth control information and devices. She was attacked by the popular Catholic radio priest Charles Coughlin, who condemned prophylactics as communist. The state legislature rejected efforts to change birth control laws, and the clinic was raided several times and forced to close in 1940.

After World War II, efforts to legalize birth control information and clinics were supported by most medical authorities, while most anti-conception laws were repealed or not enforced. However, the Connecticut law prohibiting the use of contraceptives remained until it was ruled unconstitutional by the U.S. Supreme Court in the 1965 case of *Griswold v. Connecticut*. In a seven-to-two vote, the court stated that the Connecticut law

violated "the right to marital privacy." This right to privacy was expanded in later court rulings, many of which remain contentious today.

Katharine remained active in reform movements throughout her life, especially in the work of women's health and birth control. She did not live to see the Supreme Court decision that changed the nation's birth control laws, dying in 1951 at the age of seventy-three.

Katharine Houghton Hepburn was a significant reformer who organized, agitated and educated—and that's how women's rights were achieved.

ANNA JAMES

CONFIDANT AND CONSCIENCE OF
THE COMMUNITY

S he was a small woman with a soft voice, her hair pulled back in a tight bun over a stern face marked by deep furrows and rimless glasses. She had all the appearances of a no-nonsense, hardworking, unyielding spinster. She was all that but so much more. For more than fifty years, she was the kindly, caring, trustworthy and universally cherished Miss James. Everyone in the small town visited her at the pharmacy, which was often the first stop for returning summer residents before they headed to their beach houses.

From her pharmacy on Pennywise Lane, she dispensed prescriptions to cure illness and soothe the hearts and minds of generations of Saybrook residents and visitors. For young and old she was employer, best friend and trusted adviser. She hired high school students and along with employment provided them with an education focusing on hard work, responsibility, honesty and integrity. For more than half a century, she was the confidant and conscience of the community.

Miss Anna Louise James (1886–1977) gained a place in the history books for her firsts, but even before her death in 1977 she had become a lasting legend in the history of her town. Her father was a slave on a Virginia plantation until he escaped at age sixteen and headed north on the Underground Railroad. Settling in Hartford, he married Anna Houston in 1874. On January 19, 1886, Willis Samuel James and his wife, Anna Houston, welcomed the eighth of their eleven children, Anna Louise.

Anna's mother died when she was just eight years old. She was raised by her father with help from her older sister Bertha and her husband,

Anna James bought the pharmacy on Pennywise Lane around 1917 when her brother-in-law returned to Hartford to work for a drug company. The James Pharmacy was both her drugstore and residence for over four years. *Courtesy of Old Saybrook Historical Society.*

Peter Clark Lane. Soon after graduating from Hartford's Arsenal Elementary School in 1902, the family moved to Saybrook, where Anna attended the local high school and graduated in 1905. Obtaining a high school education was not a common occurrence in those days, and it was all the more unusual for a young lady—an African American young lady at that.

Overcoming the twin bigotries of racism and sexism, Anna went on to attend the Brooklyn College of Pharmacy, where she was the only woman in her class, graduating in 1908. The following year, she became the first African-American woman in Connecticut to be licensed as a pharmacist. With the passage of the Nineteenth Amendment to the U.S. Constitution in 1920, she became one of the first women to register to vote.

It was neither easy nor common for an African American woman to successfully pursue a professional career, but Anna recalled, "There were pharmacists in my family as long as I can remember," including her brother Fritz, who operated a pharmacy in the neighboring town of Old Lyme.

Among the obstacles along her professional path was the Connecticut Pharmaceutical Association, which rejected her application for membership because she was a woman and suggested that she join the women's auxiliary.

In the late 1890s, at a time when discrimination was openly practiced and generally accepted, Peter Clark Lane (1872–1949) and Bertha James Lane (1875–1956), Anna James's sister and brother-in-law, opened what was undoubtedly the first drugstore in town with a population of about 1,400, nearly all of whom were white. Their pharmacy was originally the Humphrey Pratt House, built in 1785, which remained in the Pratt family until 1943, when it was sold. Known as Pratt's Tavern, a small room in the rear of the building served as the town's first post office. The tavern was also an important stop for the stage running between Boston and New Haven.

After graduating from Brooklyn College, Anna Louise worked a short time in Hartford before returning to Saybrook in 1911 to join her brother-in-law at his drugstore. In 1917, Peter returned to Hartford to accept a position with the Sisson Drug Company, a wholesale drug company. Anna became the sole owner in 1922 and changed the name to James Pharmacy. With Anna living upstairs, the pharmacy was open every day, even half days on Thanksgiving, Christmas and New Year's. Everyone called her "Miss James," including her niece Ann Lane, Peter and Bertha's daughter, who worked in the store and later gained fame as Ann Petry (1908–1997), author of the important bestseller *The Street*. More quietly known in her family as Louise, the children were instructed to avoid the racist label of "Aunt Anna."

Miss James made improvements to the historic building, which was originally constructed by Humphrey Pratt in the 1790s as a general store for his tavern. Since tavern owners were expected to have supplies available for travelers, the

After graduating as the only woman in her class at the Brooklyn College of Pharmacy in 1908, Anna James joined her older sister Bertha and her husband, Peter Clark Lane, at his pharmacy. At a time when discrimination was an accepted way of life, the Lane family and Anna James were among the very few African Americans living in Old Saybrook. *Courtesy of Schlesinger Library, Radcliffe Institute, Harvard University.*

small store served as a stop for the Boston–New Haven stage. A popular soda fountain was added in 1896 by Peter C. Lane and remains to this day.

Over the years, the store gained attention as the place where the Marquis de Lafayette made a purchase when he returned to America in 1824 on a triumphal tour to visit with his old Revolutionary War friends. Evidence of his purchase seems to be lost, and various stories claim that he bought wool stockings or gloves or saddle soap. Notwithstanding the uncertainties, a sign proclaiming his purchase has been prominently displayed for years as a unique and enduring advertisement.

The original Humphrey Pratt Store was located on the corner of Main Street and the Old Boston Post Road before moving to Pennywise Lane. By the mid-1850s, it was owned by James M. and Lucy Treadway. When James died, he left the building to his wife, who rented it in 1895 to Peter Lane. Peter opened his apothecary shop on the first floor. A two-story wing was added in 1922, and in the early 1930s, architect Francis Nelson redesigned the building, adding the ice cream parlor and moving the entrance to face Pennywise Lane.

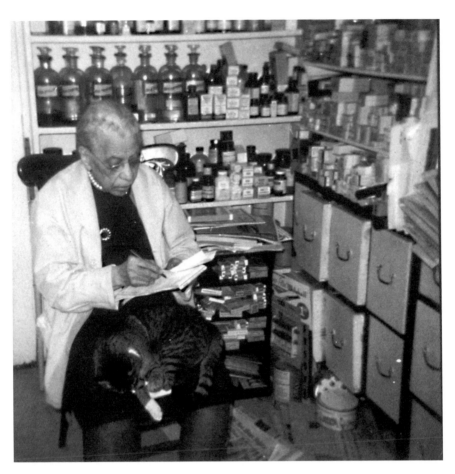

Miss James operated her drug store every day of the year until 1967, when she retired. During the store's long existence, she was known for her integrity, warmth, quality products, business acumen and good sense. Summer folks left their keys with her. High school students were hired and counseled by her. She was named Citizen of the Year in 1974. *Courtesy of Schlesinger Library, Radcliffe Institute, Harvard University.*

Miss James made extensive alterations beginning in the mid-1920s, including the addition of the pharmaceutical motif in the front and the arcaded front extension on the wing.

The interior includes display cases and glass-door cabinets manufactured by the L.F. Dettenborn Woodworking Company of Hartford and installed in 1925. The popular soda fountain still has the Vermont granite counter and the heart-shaped metal chairs and tables.

For her eightieth birthday, in January 1966, friends and family held a birthday party at the store. Some 250 showed up, and there was an avalanche of cards, letters, flowers and cakes from residents wanting to show their affection for her. That evening, members of the high school band played outside in the falling snow while the matronly guest of honor, with an orchid pinned in her pharmacy coat, accepted the many good wishes of young and old. Then, in 1974, the Veterans of Foreign Wars honored Miss James as Citizen of the Year, noting her generosity, hospitality and compassion.

When she retired in 1967, Miss James closed the pharmacy but continued to live upstairs until her death in 1977. Condolences flooded in to her nieces along with personal stories of her kindness, gentle guidance and caring attention to those in need. Her estate sold the building, and it was sold again in 1984 to Garth and Kim Meadows, who reopened it as a pharmacy and kept the celebrated ice cream parlor. The building went through several changes in ownership after the Meadows sold it in 1996, and in recent years, it has been a marketplace featuring food as well as traditional favorites from the soda fountain.

If you look carefully, you'll notice a display cabinet along the back wall with photos, medicine bottles and memorabilia from the days when Miss James was there. And if you pause to reflect about the place, you may feel the presence of a much-loved legend.

ANN PETRY

On the Street Where She Lived

Through force or choice, history is filled with examples in which African Americans have been compelled to live under wrenching and painful conditions in separate communities. Such was certainly true in the 1940s after the Great Depression and during World War II in Harlem. Moving into this poor, struggling and often violent world was a reasonably well-off young woman from a mostly white, comfortable Connecticut village. Her name was Ann Lane Petry (1908–1997). She came from Old Saybrook and was able to see more clearly and express more powerfully the reality of life than the people who had been caught in this environment for years. She did this by writing the story of Lutie Johnson, a young hardworking black mother who struggled to raise her son on 116th Street in Harlem in the 1940s. Her account became a classic American novel titled *The Street*.

The Street sold more than one million copies—the first publication by an African American to do so—was reissued and became a bestseller again in 1992. It remains the subject of academic seminars, history classes and numerous book club discussions. It is "a powerful uncompromising work of social criticism," according to Coretta Scott King. "To this day, few works of fiction have so clearly illuminated the devastating impact of racial injustice."

Ann Lane was born and lived in Old Saybrook. Her father, Peter Lane, owned the local drugstore and worked as a pharmacist before selling it to his sister-in-law, Anna Louise James. Her mother, Bertha James, the daughter of slaves, was a licensed chiropodist, a hairdresser and businesswoman who

Ann Petry first thought of becoming a writer in high school after she received encouragement from a teacher. However, she graduated college with a degree in pharmacy and went to work in the family pharmacy for several years, writing short stories in her spare time. She went on to write three major novels and several children's stories. *Courtesy of Stephen Dunn at the Hartford Courant.*

operated Beautiful Linens for Beautiful Homes, which supplied lace and linens to wealthy residents.

With a heritage of slavery and racism as well as enterprising ancestors, Ann grew up hearing stories of their struggle against oppression. These accounts along with those her mother read to her encouraged her interest in reading and writing, a passion for justice and a fierce determination to oppose the cruelties of racial discrimination.

Graduating from Old Saybrook High School in 1929, Ann followed her family's wishes to become a pharmacist and in 1931 earned a degree from the College of Pharmacy at the University of Connecticut. She returned to work in the drugstore with her aunt, who she and everyone in town called Miss James.

While working in the drugstore, she wrote short stories and observed customers who would later appear in her novels. Saybrook was used in her writing and referred to as Wheeling, New York, or Lennox, Connecticut, and Miss James was given the literary name of Aunt Sophronia.

Petry left the pharmacy in 1938 to marry George D. Petry, a Louisianan whom she met in Hartford, and they moved that year to Harlem. It was not an easy time, as the nation was still suffering from the Great Depression and the ominous rumblings across Europe that would soon lead to World War II.

In Harlem, Ann quickly immersed herself in community life and began writing for the *Amsterdam News*. Her first story, "Marie of the Cabin Club," was published in August 1939 under the pseudonym Arnold Petri. For five years, Ann sharpened her writing skills while working as a journalist. Then, in 1944, she turned her attention to working directly with the people of Harlem, becoming a recreational specialist for children at P.S. 10 and co-founding Negro Women Inc., a women's consumer advocacy group. She acted in the American Negro Theater, taught business writing at the NAACP and continued writing short stories. Her community work was recognized in 1946 when the Women's City Club of New York presented her with an award for her "exceptional contributions."

In 1943, editors at Houghton Mifflin read her story "On Saturday the Siren Sounds at Noon" in *Crisis* magazine and encouraged her to write a full-length novel. With her husband in the armed forces, she applied for a literary fellowship, and Houghton Mifflin granted her $2,400 in 1945. The following year, she completed and they published *The Street*. This story of a single African American mother examines the challenges of life on 116th Street in Harlem. It is the story of Lutie Johnson, a caring and hardworking single mother seeking security and a better life for herself and her eight-year-old son, Bub, amidst poverty, crime, human conceit and deceit. Like most great literature, it vividly conveys a story of universal human needs and aspirations. It is the work of a master storyteller.

Critics have said that Petry's writing reveals how "the interconnections of race, gender, and class can shape tragic experiences for both blacks and whites, and showed her desire to represent blacks in all of their humanity and complexity." Her writing offers "her unique perspective

of telling not only one story of black oppression, but telling many stories of black survival."

In an article she later wrote, "The Novel as Social Criticism," Petry said that novels of social criticism should critique society without abolishing individual and personal responsibility.

While working on *The Street*, Petry also wrote three stories in 1944 and 1945: "Doby's Gone," "Like a Winding Sheet" and "Olaf and His Girlfriend." These and ten other stories were published in 1971 as *Miss Muriel and Other Stories*.

Publication of *The Street* brought considerable notice to Ann Petry. This attention increased the following year (1947) with publication of *Country Place*, and the innately reserved writer, seeking to escape her uncomfortable celebrity status, moved with George back to Saybrook, where they had purchased a 1790 colonial house. In 1949, they had a daughter, Elisabeth, and in the same year, Ann published *The Drugstore Cat*. This was followed by other works of children's literature including *Harriet Tubman: Conductor on the Underground Railroad* (1955), *Tituba of Salem Village* (1964) and *Legends of the Saints* (1970).

Petry's longest novel, *The Narrows* (1953), is set in an African American neighborhood in the town of Monmouth, Connecticut. The story examines the complexities of a tragic love affair between a young African American man and a wealthy married white woman. Less well known than *The Street*, critics have nevertheless praised *The Narrows* for its forceful examination of human relationships and termed it Petry's "unheralded masterpiece."

A theme running through much of Petry's work is her passion for social justice and stories of individuals showing courage, strength of character and surviving under difficult circumstances. Her own shyness and desire to avoid publicity caused her to shun most interviews and discourage all biographers. "She was anxious for people to read her writing," her daughter wrote, "but did not want the publicity required to sell her work."

Regardless of her personal characteristics, her work was recognized with honorary degrees from the University of Connecticut, Mount Holyoke College, Suffolk University and Trinity College. In Saybrook, the Acton Public Library has named the reading room in her honor.

While in Saybrook, Ann spent much time caring for her highly respected aging aunt, Miss James. She served on the school board and from time to time exhibited her strong convictions. She opposed spending funds for athletics if it took resources away from academic subjects. Similarly, she opposed the installation of a trophy case in the high school because it only included

Ann Petry grew up in Old Saybrook, living with her mother and father above their drugstore, James Pharmacy. The cats and customers at the store were built into many of her stories, but it was moving to Harlem that led to her to write *The Street*, which became the first novel by an African American author to sell more than one million copies. She also wrote several children's stories and regularly read to her daughter Elisabeth, who also became a writer. *Courtesy of Elisabeth Petry.*

After the success of *The Street*, Ann and her husband, George, moved back to Old Saybrook, where she continued to write. Despite her fame, Ann was guarded and reserved about her public contacts. She wanted her writing to stand for itself and tended to avoid publicity. *Courtesy of Stephen Dunn at the* Hartford Courant.

sports awards. She served in the League of Women Voters, was a director and secretary of the Cypress Cemetery Association and organized Sunday school and Vacation Bible School at the Congregational Church.

In the view of one literary scholar,

> *Ann Petry is an important, if underappreciated, American writer. The first to provide emotionally complex portraits of urban working-class African-Americans, particularly women, Petry wrote fiction that is original, compelling, and timeless. Her political and aesthetic sensibilities continue to inform and influence new generations of writers, critics, and literary theorists.*

In an interview in the *Washington Post* in 1992, Ann Petry was asked about the strong female members in her family. She explained, "It never occurred to them that there were things they couldn't do because they were women." She was of that same mold.

Her daughter Elisabeth, who wrote a caring and insightful biography of her mother, *At Home Inside*, adds:

> *Beyond wanting to tell compelling stories, my mother wanted to right the injustices that the world visited on people because of their race or their gender or their poverty. She became everyone she wrote about. She was a woman of remarkable determination who overcame her limitations to leave the world a better place than she found it. And she did much by the force of her own will.*

Fortunately, "the street" where Ann Petry lived and wrote was also in Saybrook.

KATHARINE HEPBURN

At Home in Fenwick

S ituated at the mouth of the Connecticut River and overlooking Long Island Sound, Fenwick was a sanctuary for Katharine Hepburn (1907–2003) and the place she called "paradise." It had long been her summer home and later served as her year-round getaway until her death at age ninety-six.

In 1912, Dr. Thomas Hepburn and his wife, Katharine Houghton, along with Dr. Donald Hooker and his wife (and Katharine's sister) Edith Houghton, purchased a cottage in Fenwick. Both Katharine and Edith grew up in the Corning, New York area, where their grandfather had started the Corning Glass Works. The two women were similarly spirited, and both had college educations at a time when it was frowned upon by their stern family and society. The two devoted their lives to working for the cause of women's rights.

Young Katharine was one of six children and remembers going with her brother Tom to accompany her mother in her campaigns to get the right to vote for women. "Mother and Dad were perfect parents," she recalls. "They brought us up with a feeling of freedom. There were no rules. There were simply certain things which we did and certain things which we didn't do because they would hurt others."

It was here at Fenwick that young Kate played golf, tennis and swam year-round in Long Island Sound. It was also here that she and her playmates explored the "spooky secret passages" in the third-floor attic and staged her earliest acting efforts for neighbors. Here she starred in her first theatrical

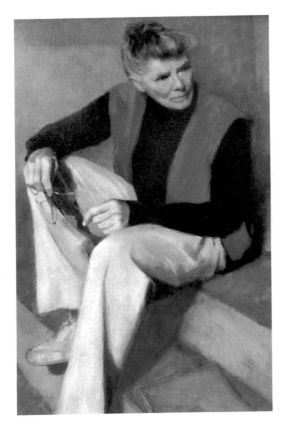

This portrait of Katharine Hepburn was presented to the Old Saybrook Historical Society in 2003 and is displayed in the archives building. Miss Hepburn had been a strong supporter and benefactor of the historical society. The portrait was done by her friend Myfanwy Spencer Pavelic of Vancouver Island, British Columbia, Canada, and originally hung in Miss Hepburn's New York town house. *Courtesy of Old Saybrook Historical Society.*

performance staged on the family's front porch—"Beauty and the Beast." "It was heaven," she recalled. "We had great track races at Fenwick and diving contests and relay races and three-legged races. It was exciting. Well, of course it was. We were all very young."

Like her mother, Katharine attended and graduated from Bryn Mawr College with a degree in history and philosophy in 1928. She spent summers performing at the Ivoryton Playhouse and in 1932 went to Broadway, where she succeeded in getting a Hollywood screen test and role in her first movie, *A Bill of Divorcement*, starring John Barrymore. When it opened at the Strand Theater in Hartford, all her Fenwick neighbors turned out to cheer her success. The *Hollywood Reporter* declared her a new star, and by 1934, she had won her first Oscar for *Morning Glory*.

Off-screen and on, Hepburn became known as an independent woman who spoke her mind and who also wore pants—a practice she had followed since the 1930s. She went on to make more than forty movies, receive twelve

Academy Award nominations and win three more Oscars for *Guess Who's Coming to Dinner* (1967, co-starring Spencer Tracy), *The Lion in Winter* (1968, co-starring Peter O'Toole) and *On Golden Pond* (1981, co-starring Henry Fonda). Her four awards remain a record for a performer.

Hepburn met Ludlow "Luddy" Ogden Smith during her senior year of college, when she was about twenty and he thirty, and the couple married. She describes him in her autobiography as a friend but never mentions that they were married. The marriage lasted only a short time and ended in divorce. "I don't believe in marriage. It's bloody impractical to love, honor and obey," she later wrote.

A few summers later, her lively spirit, strong character and good looks attracted the wealthy and eccentric Howard Hughes, who at that time was traveling around the world by airplane. His daily telephone calls provided excitement, as Fenwick cottages had party lines and everyone quietly lifted their receivers when they heard the one long and three short rings for the Hepburn line. But the true love of her life was Spencer Tracy. The two first met in 1942 when they starred together in *Woman of the Year*, and Katharine immediately found him irresistible. Their affair was an open secret that spanned nine pictures together and produced a loving relationship that lasted twenty-five years until Tracy died in 1967.

Tragedy struck Fenwick in 1938. "God sent the hurricane of 1938," Katharine later said, "and the house at Fenwick disappeared." Most of the residents had already returned to Hartford. That morning, Kate played a round of golf, shooting a hole in one on the ninth hole, and went for a swim in the sound. But the wind picked up quickly, and the tide rushed across the lawn and around their old wooden house. In no time, windows were blown out, two chimneys came tumbling over and part of the building crashed to the ground. Katharine, her mother, her brother and a good friend ran through the water and across the field to higher ground. Within a short time, the house and all their possessions had floated away.

In June 1939, the local newspaper reported, "The largest and finest summer home now under construction along the Connecticut shore is being built for Miss Katharine Hepburn, movie star, at Fenwick and is expected to be ready for use August 1, when she is scheduled to enjoy a month's vacation." The building's façade was painted white brick. Inside, decorations included Katharine's paintings and artifacts from her travels. In her bedroom, she filled a corner with samples of the many unusual hats she collected. The only photos she had of men were of her father and Spencer Tracy. On her dressing table, she kept a quote from George Bernard Shaw:

Located on the quiet side of the Borough of Fenwick where the Connecticut River meets Long Island Sound, the Hepburn house is where Katharine spent her summers as a child. The structure was destroyed and washed away in the hurricane of 1938 but was later rebuilt. It was a weekend escape and later in life her permanent home, which she referred to as "paradise." *Courtesy of Old Saybrook Historical Society.*

This is the true joy of life, the being used for a purpose recognized by yourself as a mighty one; the being thoroughly worn out before you are thrown on the scrap heap; the being a force of Nature, instead of a feverish selfish little clod of ailments and grievances complaining that the world will not devote itself to making you happy.

In Fenwick, Hepburn could be herself. She golfed, played tennis with the Fenwick pro, went swimming every morning—even in the coldest weather—gardened and painted. In between, she handled many routine homeowner chores well into her eighties. And it was also during this time that she wrote her autobiography and a book about making the film *African Queen*. Katharine frequently pedaled her bicycle to town and often shopped for groceries and household goods on Main Street. Local residents seemed to respect her privacy, although namedropping was a trendy way to guarantee listeners for the latest gossip.

It was not uncommon to see Kate on a shopping trip to Walt's Market or Patrick's Country Store, and she said that people of her generation don't think too much about it. *Courtesy of Robert Czepiel.*

Later in life, Katharine, commented on her fondness for her home:

> *Look at me. People say I've worked hard. I have worked hard, but my God, haven't I been lucky? Good health, good inheritance, wonderful parents, the whole thing. I'm like the girl who never grew up, you see. I just never left home, so to speak. I've always come back. I would never buy a house in California. I would go out there, make a picture [and] then come right back. I'm a Connecticut person, and so I always come back to Connecticut. I've had the New York house since 1931, but I don't suppose I've spent ten weekends there.*

Katharine Hepburn won many honors throughout her long and distinguished career. In addition to her four Academy Awards for best actress—still a record number—she was awarded the lifetime achievement award at the Kennedy Center in 1990, and the American Film Institute named her

KATHARINE HEPBURN
LEGENDS OF HOLLYWOOD
FIRST DAY OF ISSUE
MAY 12, 2010 | OLD SAYBROOK, CT 06475

The U.S. Postal Service issued this Katharine Hepburn commemorative stamp in 2010. The portrait, taken by photographer Clarence S. Bull, is publicity from the 1942 film *Woman of the Year. Courtesy of U.S. Postal Service.*

the top female screen legend of the twentieth century in 1999. In 2009, the U.S. Postal Service issued a stamp in her honor as part of the Legends of Hollywood series, stating "Her career and her resilient, independent persona have inspired generations of Americans. As a woman living life on her own terms, she was a valuable role model. Katharine Hepburn will remain an exemplary figure for as long as movies are shown." Her niece, the actress Katharine Houghton Grant, stated it even more simply: "She provided hope and inspiration and courage for a whole new generation of women."

OBSERVATIONS by KATHARINE HEPBURN

ON ACTING

"Acting is a nice childish profession…pretending you're someone else and, at the same time, selling yourself."

"Acting is the most minor of gifts. After all, Shirley Temple could do it when she was four."

"Acting is the perfect idiot's profession."

"I think most of the people involved in any art always secretly wonder whether they are really there because they're good or because they're lucky."

"My greatest strength is common sense. I'm really a standard brand—like Campbell's tomato soup or Baker's chocolate."

"The average Hollywood film star's ambition is to be admired by an American, courted by an Italian, married to an Englishman and have a French boyfriend."

ON WOMEN

"Being a housewife and a mother is the biggest job in the world, but if it doesn't interest you, don't do it. I would have made a terrible mother."

"If you want to sacrifice the admiration of many men for the criticism of one, go ahead, get married."

"I never realized until lately that women were supposed to be the inferior sex."

"Plain women know more about men than beautiful women do."

"Sometimes I wonder if men and women really suit each other. Perhaps they should live next door and just visit now and then."

ON LIFE

"Dressing up is a bore. At a certain age, you decorate yourself to attract the opposite sex, and at a certain age, I did that. But I'm past that age."

"Enemies are so stimulating."

"I never lose sight of the fact that just being is fun."

"It would be a terrific innovation if you could get your mind to stretch a little further than the next wisecrack."

"If you always do what interests you, at least one person is pleased."

"If you obey all the rules, you miss all the fun."

"It's life isn't it? You plow ahead and make a hit. And you plow on and someone passes you. Then someone passes them. Time levels."

"Life is to be lived. If you have to support yourself, you had bloody well better find some way that is going to be interesting. And you don't do that by sitting around."

"Love has nothing to do with what you are expecting to get, only with what you are expecting to give, which is everything."

"Only the really plain people know about love; the very fascinating ones try so hard to create an impression that they soon exhaust their talents."

"We are taught you must blame your father, your sisters, your brothers, the school, the teachers—but never blame yourself. It's never your fault. But it's always your fault, because if you want to change, you're the one who has got to change."

KATHLEEN E. GOODWIN

HER COMMUNITY CLASSROOM

More than half a century ago, on June 11, 1960, the Saybrook community held a testimonial dinner to honor Kathleen Elsie Goodwin (1901–1983), who was retiring after forty years as a teacher and principal. After dinner, a "This Is Your Life" program reviewed highlights of her life and career. "Goodie," as everyone called her (except her students—when she was in hearing range), was a firm and caring person with a magnetism that permanently captured the hearts of those who came into contact with her. The community was her classroom, and the lesson of her life was in giving to others.

Born in London, Goodie came to the United States with an aunt in 1910 when she was nine and settled in Orange, Connecticut. Her mother died a year later, and little seems to be known about her father. After attending Center School (today the Mary L. Tracy School) in Orange, she and her aunt moved to Clinton, where she enrolled in the Mill District Rural School and went on to Morgan High School, graduating in 1920. From there, she returned to teach at the Mill District School, where she remained for two years before transferring to North Madison. After one year at North Madison, she came in 1923 to the Consolidated School in Old Saybrook, where she taught various grades.

Goodie worked hard and each evening and during the summers took the bus to New Haven, where at age forty-five, she obtained a bachelor's degree from the New Haven Teachers College. "When I was taking a course that wouldn't end until late," she explained, "I would sleep on the

Goodie taught multiple generations of families. This 1923 or 1924 class photo includes Olive Simonton (second row from bottom, sixth from left) and Doris Larson Stevenson (second row from bottom, second from left). Simonton and Goodie became lifetime friends. *Courtesy of Bonnie Robinson Cook.*

bus, and the driver, who was a former pupil of mine, would wake me up at my stop."

At age fifty, she completed requirements and received a master's degree from the Cooperative Program of New Haven Teachers College at Yale. In 1941, Superintendent Joseph W. Walsh appointed her as the teaching principal of Consolidated Elementary School, a position she held for nineteen years until retiring in 1960. A former student recalled having Goodie as a teaching principal: "What this meant was that our class was on our own for short periods of time while Goodie was doing her business. This was not a challenge, for we knew what Goodie expected of us, and we were not going to disappoint her."

During World War II, Goodie taught Latin and French at the high school and English, science, history and mathematics in grades seven and eight. Each day after school, she served in the Ground Observer Corps, maintaining a station on the roof of the Main Street School to spot and identify planes. In addition to her regular classes, and after so many students

In this 1952 class photo, Janice, the daughter of Olive Simonton, can be seen in the second row (fifth from left), and Ronald Peterson, the nephew of Doris Larson Stevenson, can be seen in the second row (second from left). About half of the members of the class were offspring of Goodie's prior students. *Courtesy of Bonnie Robinson Cook.*

received harmonicas for Christmas, she decided to organize a harmonica band. She would get students together after lunch to practice, and a few times during the year they would give school performances. She often played along with them and for many years taught youngsters how to play and, if needed, helped them get instruments.

During the war, she corresponded with her former students. It was not unusual for her to receive letters from former students in distant battlefields telling her how playing their harmonicas provided comfort during difficult and dangerous times. At the annual Memorial Day assembly program at the school to honor "the boys" who died in World War II, she was barely able to control her grief when the names of her students were read from a special plaque on the gymnasium wall. She knew them and their families well and felt their loss.

From her earliest days in Saybrook, Goodie lived in the apartment above Esty's store. It was a convenient location in the middle of town, just steps from the town hall—today's Katharine Hepburn Cultural Arts Center—and

the school. In those days, the police department was located in the basement of the town hall. Ed Mosca, a former student who went on to become police chief, recalled in an interview how Goodie watched over her students as they grew up. He added, "We answered to the police commission, the selectmen and Goodie. When she walked into a room, she was still the boss."

Goodie loved meeting people while walking down Main Street and could be seen daily riding her old black bike around town, frequently stopping to chat with children, their parents and their grandparents. A longtime friend remembers when Goodie was the lifeguard at Indian Town Beach:

> Goodie wore a white blouse and skirt and a sailor's cap while she patrolled the beaches on her bike, armed with a loud whistle. Goodie couldn't swim, but she certainly knew how to give commands to whoever needed a command! Even the Good Humor ice cream vendor chose to follow her directions necessary to keep children safe. Everyone felt safe with Goodie on the job.

With her rimless glasses, unstyled hair and a sturdy figure, Goodie appeared to be sensible, stern and strict. In reality, she was warm, friendly, considerate and supportive of others. She had a good sense of humor and radiated a sense of being in charge. Bonny Robinson Cook, a former student now residing in California, remembers her teacher with fondness:

> Goodie kept a special watch over all of the students. She would alert the school nurse when a student needed help with hygiene, and bars of soap would go home with the child. She arranged for good used clothes to be quietly handed out where necessary. Students who didn't bring lunches would be offered jobs helping in the cafeteria. I just loved her bunches. I always sent her a Christmas note until she died. Sometimes I just addressed the card "Goodie, Old Saybrook, CT" and it would reach her.

Candi McConochie, another former student, recalled a surprise birthday party for Goodie:

> She walked downstairs to the cafeteria. More than a hundred kids had to keep quiet until she arrived. Then they jumped up and sang "Happy Birthday." She was a lovely, lovely lady—absolutely wonderful. She knew everyone's name, and everybody loved her.

Goodie began teaching before graduating high school and did not get her bachelor's degree until she was forty-five. She lived on Main Street and rode her bicycle around town. She was active in many volunteer organizations and started the first Girl Scout troop in Saybrook. *Courtesy of Old Saybrook Historical Society.*

Former student John Torrenti, who later became a teacher when Goodie was principal, says you had to meet her to understand. "She was just a magic person," he explained. "She was a dynamic lady, a strong disciplinarian. People understood her. They didn't try to pull something over on her. She was just a remarkable person—everybody really loved her."

Goodie's place in the hearts of so many was recognized when the *New Era* newspaper named her "Woman of the Year" for outstanding public service on January 7, 1960. She was the first woman to be honored since the award was established in 1950. The newspaper stated, "Miss Goodwin has led an exemplary life, having been active in Girl Scout work, church activities, countless town fund drives, ground observer work, and as an outstanding educator." Goodie retired at the end of the 1960 school year. She became active in several community organizations and particularly enjoyed singing in the Grace Episcopal Church choir.

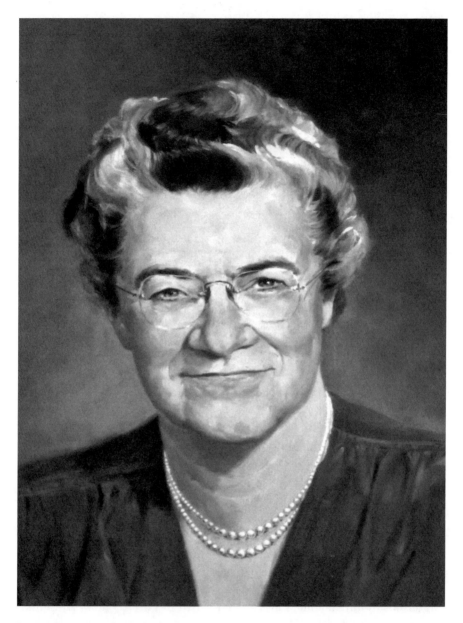

Robert Childress, noted artist of corporate and education figures and illustrator of the *Dick and Jane* series, painted this portrait of Miss Goodwin, which is still displayed in the school bearing her name. *Courtesy of the author.*

With the population increasing in Saybrook, the town established a school building committee headed by attorney Norman Sivin to plan for the construction of a twenty-six-room elementary school, and $38,000 was appropriated for the purchase of the Barbour-Bailey site on the Old Boston Post Road. As the new school was nearing completion, Goodie was given a guided tour by Superintendent Douglas Dopp on December 28, 1960.

The following month, classes began meeting there, ending the double sessions that had been held at the old elementary school since September. Joseph P. Degange was appointed as the school's first principal, a post he held until 1983. Then, at a town meeting on March 23, 1961, townspeople voted unanimously to name the new elementary school for Goodie—the Kathleen E. Goodwin Elementary School. It was a rare example of a public building being named for a living person, and a local newspaper reported her response: "But I'm not dead yet!"

When she did die, on April 17, 1983, at age eighty-two, a memorial service was held at the Grace Episcopal Church. Some 250 friends gathered on a windy, rainy day as six former students—Ed Mosca, George Maynard, Don Chapman, Bill Crocket, John Baldoni and John Torrenti—carried her casket to rest. The newspaper noted:

> It certainly came as no surprise—except perhaps to her—that the people of Old Saybrook sought to show their admiration and respect for her by naming their elementary school the Kathleen E. Goodwin School in her honor, thus conferring on her that rare distinction of making her a legend in her own time. And aren't we all glad now that the people of Old Saybrook chose to do this while she was still with us and able to savor that so-well-deserved tribute?

Always concerned about the community, Goodie was once quoted in a newspaper article as saying, "I would like to see our town keep enough space to breathe. We shouldn't lose our colonial flavor or forget our history as we grow and progress." Her small apartment above Esty's held paintings of cats and horses, while bookcases held statues and books about the animals. There were unopened boxes of Girl Scout cookies, an organization that Goodie established in Old Saybrook in 1924, and a cat hiding beneath her bed. Not an impressive material estate.

This was your life Goodie—it lives in the community and its classrooms with learning and love from the many lives you touched.

SAYBROOK SEZ

Once Upon a Time

Once upon a time, the entire nation made extraordinary sacrifices in its common determination to defeat a ruthless and evil enemy. That time was the 1940s, and young people from many small towns, including Saybrook, fought and died around the world.

During this second world war, Saybrook, with a 1940 population of 2,332, sent roughly 10 percent of its inhabitants to serve: 152 in the army, 79 in the navy, 14 in the merchant marine, 4 in the coast guard and 3 in the marine corps. Fifteen were killed. The dreadful news would arrive in a telegraph sent to parents from the War Department. Everyone in town knew, and soon a small gold star service banner appeared in the windows of their home.

They were difficult times for families. The War Department, for example, notified Mr. and Mrs. Harold W. Appell by telegram on October 28 that their son, Private First Class Wallace Appell, had been missing in action in Holland since September 23. After months of worrying and wondering, they were informed the following February that he had become a prisoner of war.

But there were also proud moments, such as the time the Van Epps family received word that their son, Private First Class Robert Van Epps, had been awarded the Purple Heart for meritorious service and gallantry in action on December 23, 1944, in Germany. That same day, they received a message from Bob saying, "I may be home soon."

With Americans fighting in far-off lands, Reverend George L. Greene, pastor of the Congregational Church, asked some of the women in his church if they thought a paper containing hometown news would be appreciated

by the servicemen of the church. Several women thought it was a good idea and went to work gathering news from around town. Then, in July 1943, they published the first issue of *Saybrook Sez*, a mimeographed newspaper with five pages. It was sent to twenty-five servicemen.

Today, we would say the idea went "viral." *Saybrook Sez* became the Facebook of the 1940s. It ran from July 1943 to December 1945 and became an immediate hit with families as well as soldiers. The editors asked their soldier-readers to "send in everything you think will interest some of the other fellows you know who are not with you," and letters began to arrive from around the world. Residents and members of other churches asked for copies to send to their members who were servicemen. It became the means of communicating between the community and its young people on active duty.

The publication was prepared monthly by a hardy band of young ladies who gathered the news and wrote the stories. They typed and ran the mimeograph machine, collated and stapled the pages and addressed and brought the package to the post office for mailing.

Serving as editors were Jean Ayer and Dorothy Stokes. Jean was a secretary at Waller, Troland, Anderson and Smith in New London and had to catch the 7:00 a.m. bus each morning. Dorothy Stokes was the church organist and a music teacher. She played the piano at the movie house at the town hall and spent her free mornings calling on people for news. Three of the volunteers worked at the new Southern New England Telephone Company on Main Street. Alice Valentine served as the business manager and was responsible for contacting boys at home or on leave. Barbara Ross was a staff worker, while Margaret "Miggie" Ebert served as illustrator. The chief staff worker was Anne Sweet, a housewife performing her duties on the paper while raising her two young children. Others included Gladys (Potter) Hanford, Marion Clark and Nancy Pendleton. The first photographer was Thomas Costen, who was followed by Frank Bleau.

The first issues were prepared in the home of Dorothy Stokes. Production work for later issues was moved from house to house, eventually being assembled upstairs in the firehouse (no longer there) behind the post office, which is now Esty's. A happy ending to hauling paper, typewriters and the mimeograph machine from house to house came when Harold White, father of Anne Sweet, offered the studio behind his house on the Old Boston Post Road as an office. It had a fireplace, a tiny kitchen, table space, good light and became a magnet for returning servicemen who stopped in to be interviewed, help write a story or look at scrapbooks kept by the staff. The

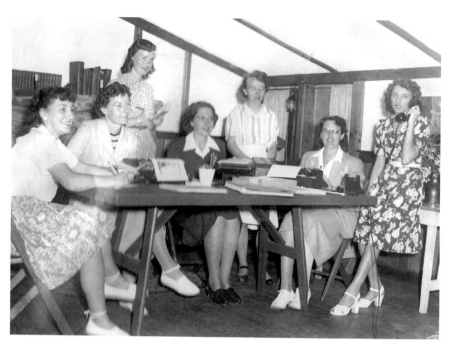

This photo shows the *Saybrook Sez* staff at work in their "luxurious" studio. *Left to right:* Anne Sweet, Dorothy Stokes, Gladys Hanford, Jean Ayer, Barbara Ross, Alice Valentine and Marion Braman Clark. *Courtesy of Old Saybrook Historical Society.*

walls were lined with maps and clippings. On the door, the women proudly hung a sign, *Saybrook Sez.*

The women worked from seven o'clock in the morning to at least eleven o'clock in the evening—five nights a week, three out of four weeks a month. Anne Sweet explains, "We worked every week night except for one week off each month. On the night when we put the paper to bed, we celebrated with coffee and doughnuts or a coffeecake. Occasionally we piled into a car or two to take in a movie somewhere—Saybrook, Clinton or Deep River. Such an excursion was rare because of gas rationing."

In addition to gas and tire rationing, there were ration stamps for many other items, including meat and sugar. Butter came with a pouch of orange dye to mix into what was probably lard but called oleomargarine. There were clothing and paper collections, and residents had victory gardens to produce food to supplement their diets. When strawberries or blueberries were ready to be picked, residents would appear at the weekly meeting of the

ration board at town hall seeking sugar for canning. Automobile headlights had the top half painted black. Volunteers were stationed on the roof of the town hall to look for unidentified airplanes. Women went to work, many for the first time, to take on jobs that were formerly held by men. Newspapers reported each day on the war's progress. It was a total war effort.

Each issue of *Saybrook Sez* contained an editorial and general news, church news, "Matchins and Hatchins" for marriages and births, quotations on the bottom of each page and all too often an "In Memoriam" on the front page. A "What We Hear from the Gang" section included reports about or from hometown boys who were on furlough,

SAYBROOK SEZ

Sponsored by The Congregational Church
September 1, 1945

Old Saybrook, Connecticut, U. S. A.
No. 26

May 7, 1945 August 31, 1945

Saybrook Sez was filled with local events and reports from servicemen and women around the world. Published monthly, it helped Saybrook residents keep in touch with the town's sons and daughters and helped the servicemen know what was happening in the hometown and with their buddies. *Courtesy of Old Saybrook Historical Society.*

receiving promotions, being transferred or describing their latest adventures in some far distant place. These eagerly anticipated letters came from ships and foxholes, front lines and bombed-out cities, training camps, Pacific Islands, England, France, Italy, North Africa, India, the Philippines and elsewhere. Each newspaper also carried the address of any serviceman who wrote in, allowing others to connect with them. And in this way, many found a buddy, brother or just someone from the hometown. "It gives me the chills just thinking of all the connections that were made," says Anne Sweet.

The paper went from the first issue of five pages to a monthly publication of twenty to thirty pages. Circulation eventually went from the original 25 copies to 250 copies for those in uniform plus a few hundred more for residents. The largest edition was 750 copies. It was sent free to servicemen

but sold for twenty-five cents to local residents to pay for photographic expenses, paper and mimeographing. It was available at Merle Patrick's store, Mr. Tiezzi's store and Miss James's pharmacy.

In the January 1944 edition, the paper reported on a talk given in Essex by First Lady Eleanor Roosevelt. After her talk, Mrs. Roosevelt stood in the lobby of the theater and greeted everyone in the audience and a *Saybrook Sez* reporter presented her with an issue of the paper. The following month, the staff received a letter from Mrs. Roosevelt stating, "*Saybrook Sez* is an interesting paper, and I am sure it is warmly welcomed by the young people of the community who are away in the service of our country. I hope that in a future edition of the paper you will send my best wishes to all those young people."

In January 1945, *Saybrook Sez* editorialized:

> *Everyone knows without being told that 1945 will be the year of decision, will demand increased determination, doing without, and just plain work. To think otherwise would be fooling no one but ourselves. But it is through that realization that our common hope for the cessation of hostilities and the establishment of a world truly at peace can become a reality, so that some time in the future someone will say: "Once upon a time, in 1945, to a world sick and weary of war, came a just and enduring peace, earned by the heroism and work of all liberty-loving people on this earth."*

Then, in June 1945, the staff wrote in another editorial:

> *As Adolf Hitler's evil and miserable system of government crumbled, as his enormous buildings and proud cities collapsed into masses of dirty rubble, and as his degraded officials deserted and died, the free people of the democracies of the world looked at the scene with hope, with pity, with loathing, and with vast relief.*

The war ended in August 1945, and *Saybrook Sez* continued each month until December, filled with reports of boys returning home. "The coming home list jumps by leaps and bounds," they happily noted. Christmas 1945 was the final issue, with thirty pages and five hundred copies. The editorial read:

> *For the first time in four years, the words 'Peace on earth, good will towards men' have a significant meaning. Familiar faces appear once more around the town, and lights gleam brightly in the windows of happy homes. For 29 months "Saybrook Sez" has wended its way to you all over the world,*

bringing a touch of home. The only way we had to show you that our thoughts were with you every minute.

Writing this goodbye arouses a feeling of nostalgia for the many evenings of ups and downs connected with the printing of "Saybrook Sez"—the many, many phone calls, letters, jaunts to the printers, pots of coffee, headaches, supply problems, arguments and laughs that worked themselves in between the lines, not to forget the heartwarming experiences of meeting the servicemen whom we interviewed and the good friendships and good times cemented with every click of the typewriter and turn of the mimeograph handle. What we mean to say is—we are sorry to close "Saybrook Sez" but glad that your being home is the real reason for it.

On the evening of September 4, 1945, a cheering crowd lined Main Street in Saybrook for a Victory Parade. And so it was, "once upon a time, in 1945, to a world sick and weary of war, came a just and enduring peace, earned by the heroism and work of all liberty-loving people on this earth."

EXCERPTS FROM SAYBROOK SEZ

"I'm now situated in France. I like it a little better than England, although I was a Yank when I left there, now I'm a Dodger. The people seem very glad to see us; we get a tremendous welcome in every village we pass through, and Old Glory is proudly waving from several French homes in each village. There are signs in every village thanking the Americans for their liberation."

—Corporal Joe Viggiano, August 1944

"It sure is great to be in an outfit that has made history, and we're going to make some more before we get through because we are going to march through Berlin just as we did Rome. Until I get back to good old Saybrook, you can think of me as one of the boys that helped to take Rome."

—Private Myron Lane, September 1944

"I've been close enough to it and have seen the suffering and destruction caused by the ruthless Nazis here in Italy. Since

I can speak their language, many of the natives have told me of the terrible things done by the enemy. I've seen towns completely destroyed, not a building left, and people living just like animals. One doesn't realize how terrible war is until he actually sees it. I know we are all proud to help destroy such ruthless enemies as the Nazis."

—Staff Sergeant Leon Negrelli, November, 1944

"I got out of the hospital a week ago and left for rest camp the next day. I was pretty much excited about that because the chance to see and visit my long lost relatives had arrived at last. In order not to lose time, I didn't stop along the way—even for dinner or supper. When I met my aunts and uncles and first cousins for the first time, they all broke down with tears of joy, and needless to say, I did too. Before I got there, I thought I'd have to eat and sleep in some camp nearby and didn't dream that they would have food and lodging enough for me after all they had been subjected to. But it turned out that each individual family of my relatives (four or five families in all) wanted me to sleep and eat at their respective homes! When I was in one house over an hour, another group of relatives would come in and say: 'You've had him long enough, we want him over at our house now!' and that's the way it was all the time. I might forget a lot about Italy, but I will never forget this visit."

—Private First Class Gildo Baldoni, Italy, April 1945

"We are in the town of Crailsheim and are living in the few houses that are still standing. We had a very hard battle trying to capture this town, and the Air Corps was practically forced to level it to the earth. I don't know the name of the town in which I was wounded. It happened just before my company crossed the Danube River. About six German rockets hit the roof of a stone barn I was lying next to, and it caved in on me. I was quite fortunate…two of my buddies were killed next to me. A tank driver dug me out and located an aid-man. He got hit by shrapnel while helping me."

—Corporal Charles Hosmer, Germany, July 1945

"Wallace Appell during invasion of Holland was in a glider headed for Arnheim. His glider packed with five men, ammunition and supplies never reached its destination, for it was shot down and landed about 35 miles from Amsterdam. Picked up immediately by the Germans, possibly SS men, as prisoners, they were made to walk for three days through Holland [and] then were put in box cars and forced to travel for a week to Limberg just outside of Frankfurt…forced to fill bomb craters…sent to camp in Austria…tea for breakfast, soup for lunch, and bread and a couple of potatoes for dinner."

—Private First Class Wallace Appell, August 1945

STEFFIE WALTERS

Point of Destiny

S aybrook Point is an incomparable location and holds a uniquely special place in the history and culture of the shoreline and beyond. Ever since the Indians came to fish, the Dutch came to trade and the English came to chase them away and settle the place, Saybrook Point has been what tourist officials call a "destination point." Contributing to that attraction is the Dock and Dine restaurant, but over the years there's been a succession of claims to that prime piece of land where the Connecticut River meets Long Island Sound.

After Gardiner's first fort was destroyed by fire, another was built in 1647 on what became known as New Fort Hill or Battery Mound. While archaeologists and historians from the Mashantucket Museum are currently seeking evidence to locate that fort, many people believe that the second fort was located at the present site of the Dock and Dine restaurant.

In January 1808, much of the land at Saybrook Point was sold at auction to Abner Kirtland for $391. However, the fort remained until 1870, when the property was acquired by the Connecticut Valley Railroad. Battery Mound was leveled to make way for railroad tracks and a roundhouse, and soon thereafter a rail line was laid on a causeway over South Cove to a station in Fenwick. That work removed the remains of the old fort, and even the grave of Lady Fenwick, wife of George Fenwick, had to be moved from the fort area to Cypress Cemetery.

Rail service over the causeway to Fenwick lasted until 1915, when the Saybrook Point roundhouse was abandoned, but it was not until 1922 that

both were dismantled. When the railroad ceased operations, it gave title to some of the land to the State of Connecticut with the stipulation that it be used only for "monumental purposes." The remaining strip of several acres along the waterfront—from the end of College Street to the Dock and Dine Restaurant—was sold in 1934 by the financially troubled railroad to Albert Dudley of Old Saybrook and his partners from East Haddam. They incorporated the area as the Old Saybrook Dock, repaired the dilapidated steamboat dock and began developing the property.

Town tax records indicate that Dock and Dine was constructed in 1940, although there seems to be few other records regarding this. Dudley and his partners held the property until June 1947, when they sold it to J.T. Downing of Old Saybrook. Downing kept the six-acre site except for a small piece he sold in July 1951 to Howard Clark, who had a bait and tackle shop and fish market at the end of College Street. Downing expanded the restaurant and in 1952 sold it along with the rest of the property to John P. Caval from Newington, who owned and operated a tool and dye business there.

The shoreline restaurant was popular with visitors, who were drawn to the waterfront to dine, fish, boat or simply watch the tankers and barges. Mr. Caval ran the place for several years, but spending winters in Florida was becoming a higher priority for him. He met Eddie Walters, owner of a popular German restaurant in New Britain, on a fishing trip and offered to sell Dock and Dine to him. When Eddie visited the place, he found it closed and neglected from a hurricane the previous year. He returned a second time with his wife, Steffie, who fell in love with the place. They sold their restaurant in New Britain and in 1958 purchased Dock and Dine at Saybrook Point. They went to work to restore the building and revitalize the menu.

Steffie Walters became the first woman to own the restaurant and property and is a case study of the classic American success story. Born in Austria in 1911, Steffie grew up working in her parents' bakery and restaurant. In the early 1930s, she left Austria to come to the United States. After spending a short time with her aunt and uncle in Kansas, she moved to New Britain, where she could find friends with similar backgrounds—people who could "speak her language." One of those friends was Eddie Walters, who she soon married. The couple eventually had two daughters, Marlene and Karen.

Together, Steffie and Eddie bought an old grocery store in New Britain and converted it to a German restaurant, which they named the East Side Restaurant. They worked twelve- to fifteen-hour days and developed a thriving business. But after fourteen years, they had become tired from the

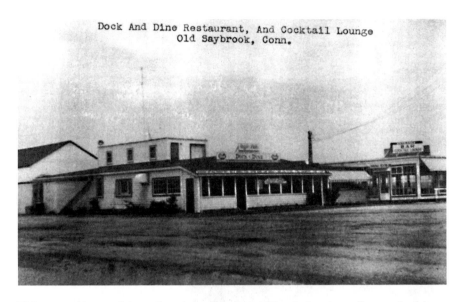

Dock And Dine Restaurant, And Cocktail Lounge
Old Saybrook, Conn.

This postcard is one of the earliest views of Dock and Dine. Its location at the mouth of the Connecticut River made it a popular destination for sightseers. In the early 1940s, the area also included a float and ramp for a seaplane and a steamboat dock. *Courtesy of Roy Lindgren.*

constant demands of the business. Steffie recalls saying to her husband, "There's got to be an easier living." As it turned out, it was not easier, but it may have been more pleasant at Saybrook Point.

The popularity of "Steffie and Eddie Walters' Dock and Dine" grew. They made many improvements to the building, the property and the menu. An open take-out area was enclosed, and dining expanded. The parking area was improved and expanded with fill provided by the state from the new Route 9 construction, and a seawall was constructed with a concrete walkway along the river. Around 1966, they built a smaller take-out restaurant called the Sand Bar, which was run by their daughters, Marlene and Karen. They also built a miniature golf course nearby. Steffie Walters explained that the idea came from a couple who frequently ate at the restaurant. The couple, who designed custom miniature golf courses, said, "You have a beautiful piece of property, but it is used only for parking. Why don't you build a golf course?" Steffie and Eddie were persuaded and began going to local boards to get zoning changes and permits they needed. Unfortunately, Eddie Walters died in 1969 and did not see the miniature golf course completed. Soon thereafter, Steffie sold the restaurant but kept the Sand Bar and a small piece of nearby land, where she built the mini-golf course in 1971.

Left: Businesswoman Steffie Walters celebrated an energetic one hundred years on Christmas 2012. She has fond memories of the people she and her husband, Eddie, met while managing the Dock and Dine. *Courtesy of the author.*

Below: This postcard advertisement shows an aerial view of Dock and Dine as well as its interior. The message on the back temptingly suggests that you "enjoy a delicious meal or cocktail as you watch boats cruise by." *Author's collection.*

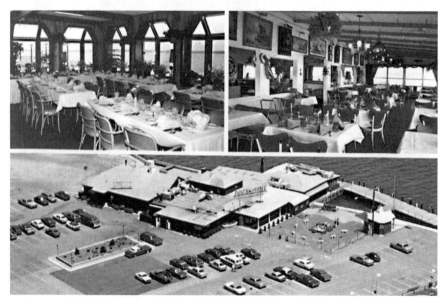

Arnold and Rose Benak purchased the restaurant in 1969. Arnold (1914–2011), another immigrant success story, was a native of Hungary who came to the United States at age fifteen. He worked as a busboy and attended high school in New York to learn English. He became the manager of several highly respected restaurants, including the one where he met his wife, Rose. Mr. and Mrs. B, as they were fondly called by patrons, expanded the facility until it had three dining rooms and the Seagull Lounge. Arnold was always the gentleman, well dressed and forever holding doors and helping customers.

The Benaks ran Dock and Dine until 1981, when they sold it to William Winterer, owner of the Griswold Inn in Essex. Winterer was a member of the state historical commission, founded the Steamboat Dock Foundation in Essex and was instrumental in forming the Ivoryton Playhouse Foundation. He thought it was a big mistake to have demolished the nearby Pease House, which he viewed as the potential Griswold Inn of Saybrook. However, his views of Dock and Dine were less favorable, and he planned to establish a boat service from Saybrook Point up the Connecticut River. The proposal drew many complaints from neighbors, who worried about the number of buses it would attract. Winterer made some improvements but sold after just five years, his heart apparently not in the non-descript Dock and Dine.

By 1989, Steffie Walters was ready to dispose of her remaining property. As the story goes, she walked into town hall and said to First Selectwoman Barbara Maynard, "I want to sell Saybrook Point, and you've got to buy it." A surprised Ms. Maynard noted the town's existing financial commitments but was intrigued by the possibilities. When a private marina developer took an interest in the site, the town decided to move and bought the 2.3 shoreline acres with the Sand Bar and miniature golf facility for $3.2 million.

Since 2001, Saybrook's parks and recreation department has maintained the old Sand Bar as the Pashbeshauke Pavilion and rents it to Saybrook residents and civic organizations. It also maintains the municipal mini-golf course, where an estimated thirty thousand rounds are played each season, generating sufficient funds to offset other recreational expenses. The course gets high grades and draws both tourists and local families to the shoreline. In an atmosphere of sea breezes and sailing boats, no one worries much about their score. It is one of the very few publicly owned and managed mini-golf courses in the state. Through the vision and determination of Steffie Walters, enlightened public officials and a supportive community, the old Sand Bar restaurant and the mini-golf course have become valuable public assets.

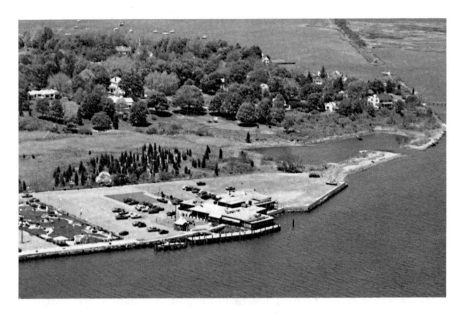

Saybrook Point attracts many visitors and sightseers for its restaurants, water-based activities, history and environmental features. In 1989, the town purchased the Sand Bar Restaurant, made improvements and renamed it Pasheshauke Pavilion. *Author's collection.*

The restaurant changed hands again in 1987, when it was purchased by Jon Kodama, a businessman who owned other restaurants in Mystic and Newport, Rhode Island. In more recent years, some major natural disasters have devastated the building. Southeastern Connecticut and especially shoreline areas suffered major damage when Hurricane Irene blew by in August 2011. Surging water tore up the docks and destroyed the restaurant's interior. As a result, there was neither docking nor dining for a year while the building was thoroughly repaired and renovated. Everything inside was gutted and redone or replaced. A completely new kitchen was installed, and the interior was rearranged. These were the most extensive renovations since the Dock and Dine had opened in the 1940s.

The new facility provided a bright interior with incomparable views of the water and reopened to enthusiastic customers in September 2012. But that was not to last long. One month after reopening, in October 2012, another storm struck. Hurricane Sandy ripped open the roof and left eighteen inches of water in the building. High water and strong waves pounded the heavy wooden docks and left them in shambles. The damage was estimated at close to $1 million.

Visitors still come to the spot where the river meets the Sound at Saybrook Point to see the historic Saybrook Fort site; the statue of soldier-engineer Lion Gardiner, who built the original fortification; the monument to George Fenwick, the leader of the 1635 settlement; the remaining features of the railroad turntable; and the environmental features of the nearby marshlands and surrounding park. But it will be some time before boats or banquets are found again at Dock and Dine. Until then, its long history, unique geography and Steffie's mini-golf will keep the area a destination point.

MARION HOUGHTON HEPBURN GRANT

INDEPENDENT AUTHOR

Although she came from an upscale and accomplished family, her goal was to get married, and her preferred form of exercise was housework. You'd think she was just another society dame dabbling in superficial housework while leading a fashionable life of privilege, but her life was lived with intensity and energy as a socially minded activist, historian and author.

Marion Hepburn Grant was one of six children—three girls and three boys—born into an illustrious family that included the founder and presidents of Corning Glass, U.S. senators and representatives, ambassadors, philanthropists and movie stars. The daughter of Dr. Thomas Hepburn and Katharine Houghton Hepburn, the noted suffragette and birth control advocate, Marion grew up in Hartford, attended private schools and spent summers in Fenwick. Her early education and later experiences reflected a deep concern for social justice, a concern similar to that of her mother's.

When she was seventeen, Marion worked at the Hull House in Chicago. Just two years later, she was working for the United Federal Workers of America, a union of government employees affiliated with the Congress of Industrial Organizations in Washington, D.C. One summer she worked with Quakers, helping poor whites in the hills of Tennessee. Other summers she traveled abroad, and she twice spent summers on the South Carolina plantation of Pulitzer Prize–winning novelist Julia Peterkin, who specialized in the African American experience.

After attending Oxford School in West Hartford, Marion went to Bennington College in Vermont, where she majored in creative writing and studied labor, government and sociology. Although strongly drawn to social issues and causes promoting justice and democracy, she easily admitted that what she really wanted was to get married.

Quite different from her siblings, Marion's preferred exercise was housework. She thought it was more sensible than golf or tennis, both of which she abhorred. "It's a much more sensible form of exercise than sports," she said. "At least when you're done, you've accomplished something."

Author and activist Marion Hepburn Grant told the story of some of Saybrook's most notable people and places. She is the most prolific chronicler of Saybrook's past and has written books about Fenwick, the Hart family and David Bushnell. *Courtesy of Katharine Houghton Grant.*

The man of her dreams was Ellsworth Grant, an alumnus of Kingswood School in West Hartford and Harvard. The two first met when he cut in on her at a dance he had not wanted to attend. "I had found the right husband, and I knew…that the job of being a wife was not an inferior one," she explained. They were engaged on Valentine's Day 1939 and married at her parent's home the week after they both graduated. Marion and Ellsworth shared a passion and commitment to social justice, community action, writing and history, and these became the center of their efforts and contributions to the larger community.

Marion took her community to heart. She was the co-founder of the Urban League of Hartford, president of the Junior League and president of the women's association at her church. But it was to writing that she was drawn, and it was in history that she found the most productive outlet for her diverse interests and passions. She wrote three books related to Hartford: *Guidebook to Greater Hartford* (1966), *In and About Hartford: Tours and Tales* (1978) and *The City of Hartford 1784–1984* (1986). But it was mainly the books related to Saybrook and Fenwick, the exclusive coastal

enclave where her parents had summered since the early 1900s, that she explored history.

In 1971, for the 100th anniversary of the founding of Fenwick, Marion agreed to write a book to mark the centennial of the borough and its influential inhabitants. "We know so little about the places where we actually live," she said, "and it is so important to have knowledge of one's roots." She described the book, titled *The Fenwick Story*, as a "community biography." Writing to her daughter, the actress Katharine Houghton, she reported that the book was "more of an assignment than I thought it would be…but fun." She wrote of her neighbors, the owners of the wood-shingled mansions referred to as "cottages," saying that she wanted to give the book some color: "Before the book was published, I let everybody read what I wrote about them and their families. I told them that if I didn't write 'warts and all,' it would be boring. No one asked me to take anything out." After publication, a West Hartford newspaper reported, "The result is a fascinating account of interesting personalities, family feuds, the organization of a borough form of government and the attendant political intrigues, changes in family fortunes, and a growing feeling of pride and love for their community."

After writing about her prominent Fenwick neighbors, Marion next set her sights and talents on Saybrook's notable Hart family, telling her own family, "The Harts were an exceedingly peppy tribe." Among the many "peppy tribe" members was General William Hart, a Revolutionary War veteran and a western land speculator. His brother Elisha was the father of the seven beautiful Hart daughters. Marion fittingly concluded that "there are so many stories to tell I could write a book on each one."

Marion's publications are still widely read and valued, although recent scholarly work has uncovered new evidence relating to the legendary romantic affair of one of the Hart sisters. Relying on a novel written by Marguerite Allis based on the lives of the Hart sisters, *The Splendor Stays: An Historical Novel Based On The Lives Of The Seven Hart Sisters Of Saybrook, Connecticut*, Marion repeated the popular and long-told story of a romance between Jeannette Hart and Simon Bolivar. However, in recent years, scholars have uncovered new evidence and have concluded that Jeannette never met Bolivar nor went to South America. Recognizing the possibility of uncovering new information, Marion wrote in the acknowledgements that her account was only the beginning and that "hopefully, it will serve as a catalyst for the collection of additional stories…to provide an even more detailed insight into the lives of this fascinating family."

Marion supported social and political causes including minority rights, education, jobs for the disadvantaged and improved city/suburban relations, but her outspoken views made it impractical for her to run for public office. Interested in history and politics, her strong beliefs led her to help form Hartford's first Urban League. Always passionate and usually partisan, she stimulated others to think and often enjoyed a provocative conversation on topics she thought important: the world, politics, religion, family, work ethic and morality. A friend once said of her:

Nothing sparked her hazel eyes as much as a different point of view or a dangerous controversy. And once you became involved in one, you were involved for life. Years could pass, and one sunny morning she would smile her mysterious little smile, and out would dart some outrageous "fact" that she had gleaned from an obscure pamphlet.

Marion distilled her mission as one to "educate powerless people about the way the system works and how they could empower themselves to use it to their own advantage." In later life, her view of the world mingled politics and religion and took a decidedly conservative turn. She opposed public schools, labor unions, the so-called welfare state, feminists, liberal churches and clergymen. She thought creationism and evolution should be treated with equal respect. She summarized her social and political philosophy stating that it was "essential to a free society that the three prime powers of 'Bread, Soul, and Clout' be kept separate. They need to work together, but not to control the community at large."

Marion made history come alive because she saw it as a fascinating and illuminating story about real people with strengths and weaknesses. Her husband and noted fellow historian and sometime collaborator Ellsworth Grant says that Marion was "a marvelous combination of idealism and practicality. She had a tremendous curiosity about people and social causes, as well as a tremendous urge to make things better for where she lived."

It was sadly prophetic when she wrote to her daughter that she was almost finished with her work on the book *The City of Hartford*. "I hope it will do some good," she wrote. "Take care, little one." It would be Marion's last chapter.

BOOKS BY MARION HOUGHTON HEPBURN GRANT

A Guidebook to Greater Hartford (1966)

Passbook to a Proud Past and a Promising Future (1969)

The Fenwick Story (1974)

The Infernal Machines of Saybrook's David Bushnell (1976)

In and About Hartford: Tours and Tales (1978)

The Hart Dynasty of Saybrook (1981)

Fort Saybrook at Saybrook Point (1985)

The City of Hartford, 1784–1984 (1986)

Chapter 17

BARBARA J. MAYNARD

"Town Mother"

by Ann Gamble

E very once in a while, the stars align and someone comes along with just the right set of skills at just the right time. Barbara Maynard is such a person. Her contagious enthusiasm and talent for consensus building laid the foundation for the town's future while preserving its rich history.

The former first selectwoman began her relationship with the town as "a summer kid, brought up by my grandmother and grandfather. We'd come up early in the spring and stay all summer long. I went to school for a time in New Britain, but eventually my family moved here, and I went to High School in Old Saybrook." This is where she met George Maynard, her husband of more than sixty-five years.

Barbara, now in her mid-eighties, reminisces about those early days. Of the twenty-four students in her 1944 graduating class, only four were boys, "which made for a difficult prom," she joked. "But I had a date—I had him," she continued with a smile toward her husband. "It was World War II. A lot of the boys lied about their age and went into the navy."

Little did she know that decades later she would be the first woman to hold the top office in Old Saybrook. It was a position she handily held for sixteen years straight and whose role she likened to that of "town mother." "It's been a fun life—I've done so much," she said. "It's hard to remember all of the steps we took. We had three boys within six years, which kept us busy. George was a farmer and then a builder...he owned the hardware store and then he retired." During that time, Barbara helped with the bookkeeping,

worked in the hardware store, belonged to several clubs and served on various town boards and commissions. "I just love this town. I've been so fortunate," she confesses. "Before I was first selectwoman, I was the registrar of voters for fourteen years. Having the name Maynard didn't hurt either; everyone knew the Maynards. At one time, we had twenty-one first cousins in school at the same time."

Barbara credits her father-in-law, George Maynard Sr., with the start of her political career:

> *He was very active in politics. He told me that the registrar of voters was retiring and asked if I would like to run. I was nominated by the Republican Town Committee and was there for fourteen years. At the time, a lot of women were registrars and town clerks because they were basically record-keeping jobs and they didn't pay enough for a man to take it.*

But first selectman was another story. "We had a town committee meeting once," Barbara recalls, "and there was a Democrat in office that was not real popular. They asked if I would run, and I said, 'Never. The town fathers would roll over in their graves—we've never had a woman first selectman.'"

The committee persisted, so Barbara said, "You go home and talk to your families and see how they would feel about a woman—not just me, but any woman—in office." She then went home and talked about the opportunity with her family. "They said, 'Yeah, go for it!'" she recalls. "We [the committee] came back together a month later. There were no negative remarks, so I became the candidate…and we won handily." That was back in 1973. Barbara held the office until 1989. "I didn't like lawn signs," she recalls, "so I sent out a series of three postcards each time I ran. They were historical postcards we had enlarged with a handwritten message printed on the back, and I had a group of women come in to address them by hand. That's all I did."

George Maynard had retired by the time his wife had become first selectwoman, and as Barbara recalls, "He was having a lot of fun. He was very involved." But this is where George interjects, likening himself to Prince Phillip in that he was "two steps to the right and two behind" his wife. "That wasn't true—he helped me a lot," Barbara contradicts. "He has more common sense in one finger than I have in my whole head. If I came home with a problem, he'd help me work it out and give me ideas."

Barbara reminisces about her days in office:

I always felt I was like the town mother. It just seemed to run that way, you had all kinds of problems, and you had to provide for the health, safety and welfare of people—just like you do for your family. It was a wonderful job and I loved every single day.

As to whether she prefers the title "first selectman" or "first selectwoman," Barbara says, "Well, it was 'first selectman' until Governor Ella Grasso came down here one time. She saw the sign over the door and said, 'You are not a man; you're the first selectwoman—just like we have congresswomen now.' So that kind of changed it. It was 'first selectwoman' after that."

Ella Grasso was governor from 1975 to 1980, and as Barbara recalls:

She came down and held office hours here. We were covered by four local newspapers. We would let them know the governor was coming, and they all came and followed her around. She went down to the main room in the old town hall, where she talked to them for awhile. Then she went up to the offices and to the schools and came back and said, "I feel like a mother duck—everyone is following me around."

Barbara laughed while doing a fair impression of the popular Democratic governor. She enjoyed a warm relationship with Grasso and another Democratic governor, William O'Neil—a testament to her broad appeal.

Barbara is a humble woman and acknowledges that she had help along the way. "I had the best people to work with for sixteen years," she said. "We had town road foreman Ron Baldi, who was a fire chief and was born and brought up here. He knew everyone and every road, every hydrant, every pothole. We went from tarring roads to paving roads." However, she does recall two particular victories with a sense of pride:

When I first came into office, we had no town garage, dog pound or transfer station. We had a condemned town dump—it had been condemned for about five years—and our health director Bob Saunders would say, "You've got to clean up that dump." Well, that sounds easier than it is. So I found a couple of locations that could be used for a transfer station. It would be the eighth transfer station in the state. The first location was voted down because someone said, "All you would be doing is looking down on dirty toilets and bath tubs." People didn't really understand what a transfer station was. The town engineer, Fred Radcliffe, and I went around to see

the other seven, some of which had been going for four or five years. We asked them [the engineers] what they would do if they had to do it over. First we had to buy the property. We bought that whole thirteen acres. We got it for a very good price, even for back then, and were able to turn the far end of it over to the Exchange Club so they could have the recreational skating pond. That was a good deal. We were able to open the transfer station about a year and a half after I got into office.

Another victory came in 1985 when the town acquired Saybrook Point:

Ellsworth Grant, who lived in Fenwick and was kind of a state historian, came to me and said "We've got to buy Saybrook Point." I said, "That's fine, but I'd rather have someone give it to us." We contacted DEP because they had control after the railroad closed down. They agreed that the town should have it and agreed to sell it to us for a dollar. To get people interested in making it a park, we contacted Larry Rainey, an eighth grade civics teacher. We talked to the eighth grade class and asked if they'd like to buy it for the town. They brought in pennies and collected them in a leather pouch. The treasurer of the state came and received the bag of pennies from the class president and presented us with a deed.

At the time, it [Saybrook Point] was just a big empty gravel pit that had been used to build the causeway, which was originally a railroad crossing. We formed the Saybrook Point Monument Association—it took us five years. We used dredging material and fill from other towns and finally filled up the hole. Carol Scully created a design, and the result is the park around the statue of Lion Gardiner, which has been there since the 1930s. The park was dedicated [in 1985] during the 350th celebration of the Saybrook Colony.

Maynard was also instrumental in purchasing Harvey's Beach. "I knew Violet Harvey," Barbara said, "and after her husband died, she came in and said, 'I don't know what to do with Harvey's Beach.' I said, 'Well, the town needs more beaches.' So we made an arrangement with her to pay her off over five or seven years, and we were able to open it to the public on a pay-as-you-go basis."

Maynard has fond memories of the large-scale town events of the '80s:

One thing we had that really brought people together were celebrations. People who weren't interested in planning, zoning or anything else were

instilled with enthusiasm about celebrations. We had great coverage from all the newspapers and the radio. They couldn't not know about it. People were better informed back then. It was easier to get people involved because people knew about it.

Was she also the town cheerleader?

I think so. I think we started it. Every year I looked for what we could celebrate. If you have the enthusiasm yourself, it spreads and spreads. Truthfully, they did need a cheerleader, and I had the opportunity to give this stuff to the press. We were able to get people to donate money. Maybe we put a little in the budget, but it was really the community, people from all seven Saybrook Colony towns.

We had the American Wind symphony come up on a barge, which became their music shell. The musicians were music school students from Philadelphia. Everybody went to that. We asked Kate Hepburn, and she said she'd come but needed a ride. George went to pick her up with her secretary, Phyllis, and her brother Dick. She had a front-row seat. The kids knew she was there, and they played their hearts out for her. At one point, Kate got so excited that she jumped up out of her chair and jumped from the dock to the barge. I remember thinking, "Oh no, how the hell am I going to get Kate Hepburn out of the water?" Kate made the jump, got up on stage, talked to the kids and led the orchestra. She just became a star to all of us.

Now that it's all over, Barbara is finally able to reflect and devote more time to other interests. Until recently, she served on the board of the land trust. She is still a member of the historical society and has been a member of the garden club for over fifty years. "That's another group [the garden club] you take pleasure in working with," she said. "They love open space, they want it to be pretty around town and they don't mind working on the barrels on Main Street." "Actually, one criteria for membership is to be able to bend over to work on the Main Street barrels," Maynard laughed.

Some might think it frustrating to watch her successors handle her former job. "Not at all," she said. "I always felt whatever decision they made, it had to be the best decision they could make. You are not very powerful as first selectman. It requires leadership, cooperation and involvement, but it's not 'I said you're going to do this.'"

In addition to their three sons, the Maynards have four grandchildren and four great-grandchildren, some girls among them. "When we first

As first selectwoman, Barbara J. Maynard had the task of apologizing to Yale president Kingman Brewster for the poor behavior of Saybrook residents nearly three hundred years earlier. Local rowdies destroyed bridges, damaged ox carts and removed books that were being hauled to the relocated Yale College. *Courtesy of Barbara J. Maynard.*

had a girl in the family, I went out and bought every pink ruffle thing I could find," Barbara confessed. "I was so sick of smelly sneakers and dirty jeans, which is what I got with the boys!" The only political office held by any of their offspring is that of their son Barry, who serves as town tax collector.

Barbara has two books to her credit: *Faces and Places* (2005) and *Old Saybrook*, which she co-authored in 2010. She was also instrumental in bringing "Glimpses of Saybrook in Colonial Days," by Harriet Chapman Chesebrough, to print. "Before the Celebration 350, I was looking through files with town clerk Charlie Dougherty," she recalls. "We went through an old vault and came across a handwritten manuscript by Harriet Chapman Chesebrough of stories told to her by her grandfather." R.R. Donnelley & Sons Company published the manuscript in honor of the celebration.

Did Maynard consider a run for state office? "After first selectman, I was asked to run for representative for the remainder of a term," she says, "but I didn't make it, so I didn't go any further. I still had interests in the town

First selectwoman Barbara J. Maynard recognizes Miss Anna Louise James for being one of the first women to register to vote. That right did not come until 1919, when the U.S. Congress passed the Nineteenth Amendment, which states, "The right of citizens of the United States to vote shall not be denied or abridged by the United States or by any state on account of sex." *Courtesy of Barbara of J. Maynard.*

and was glad to be around my own house. I hadn't been able to do that in a long time."

Barbara offers the following advice for young women:

> *Get interested—serve on boards and commissions. If you have kids in school, serve on the PTA/PTO. Go to meetings once in awhile, especially hearings, and think about giving some time. I remember one day when we honored volunteers—110 members, alternates, ad hoc people. It was amazing the number of people who were involved in the government in one way or another.*

Still passionate about the town she first grew to love as a young girl, Barbara encourages others to share her passion: "I would like people to appreciate that they live in a small town with a town meeting form of government, but that might change if people don't take an interest and come to town meetings. We can stick to our town meeting form of government, but people have to be a part of it."

Chapter 18

WOMEN'S CLUB

DONE DOING GOOD

This is a story about fifty-seven years of friendship, self-improvement and service to the community. It is the story of the Old Saybrook Women's Club and the good work it did until it disbanded. The women were able to help many but could not help themselves, so they closed the books just as they existed—surprisingly quiet.

Many residents may not realize the absence of the Women's Club, but those who have been helped are fully aware: the libraries that received publications, the children who received scholarships to attend High Hopes Therapeutic Riding Academy, the families that were kept warm or residents who needed help with the high cost of heating fuel, those who needed a meal at the Shoreline Soup Kitchen or fresh vegetables from the Common Good Garden, those who received dental services, those who welcomed a holiday basket and those who needed funds to help them through the catastrophe of a loss from fire.

But that's not all. There was support for the Battered Women's Shelter, Connecticut Hospice, the Drug and Alcohol Action Group, parks and recreation programs, the police and fire departments, summer concerts, Bikes for Kids, the school music department, contributions to help beautify the center strip on Main Street and much more. Perhaps the best-known program was the scholarship program for high school students. The first scholarship, $250, went to Carol A. Spencer at Old Saybrook High School going in 1958. By 1961, the amount had increased to two $300 scholarships, which were presented to David Brainard and David Manston. In recent

The Women's Club of Old Saybrook at the dedication of the Kathleen E. Goodwin School, 1962. *Front row, left to right*: Dorothy Hull, Ethel Hull, Mildred Sposato. *Back row, left to right*: Alice Hopkins, Olive Symington, Else Kavelius, Kathleen Goodwin, Myrtle Abetz and Aldea Pettijean. *Courtesy of Old Saybrook Historical Society.*

years, the scholarship has grown to $1,000–$2,000, and over the life of the Women's Club, 169 students have been beneficiaries.

Formed in 1955, the Women's Club quickly grew. At its peak, it had more than three hundred members, and there were still over two hundred members when it disbanded in 2012. The club began when a small group of Old Saybrook women, including several newcomers to town, were talking casually about starting a women's club. One of the women, Mrs. Willis W. Gardner, proclaimed, "The aim of this club shall be to represent Old Saybrook in working together on any project—civic, educational or recreational—for the betterment of the community. The purpose of the club is to be active in the interest of civic affairs, in art, in music, literature and other related fields."

On April 18, 1955, a group of eleven women established the Women's Club of Old Saybrook and elected temporary officers. A few days later, the

local newspaper announced its formation. They met again the following week in the parish house of the Congregational Church. With small changes, they agreed to adopt the by-laws of the Essex Woman's Club. Several committees were established, including ways and means, home economics, literary and a welfare committee to look into making decisions for using funds.

At the next meeting, the following elections were made: Mrs. Willis W. "Zoe" Gardner, president; Mrs. Clayton Welles, vice-president; Mrs. Stella Nelson, recording secretary; Mrs. Edward Bengston, secretary; and Mrs. Carl Truebe, treasurer. According to the meeting's minutes, the club was to be for "the benefit of its members, for their enjoyment and pleasure, with various activities such as arts and crafts, literature, music, dramatics, etc. The primary reason being to make money to support some civic improvement for the town of Old Saybrook."

In the first few weeks, fifty women registered to join the new club, and within the year there were over one hundred members who joined to meet other women and work toward a common community goal. They held monthly meetings that included entertainment or educational programs.

In February 1956, Roger Tory Peterson, the nationally known author and traveler and Old Lyme resident, gave an illustrated talk on wild America. The following month, there was a fashion show with coats and hats, gowns and accessories presented by Sage Allen of Hartford. Not to be outdone, a later meeting featuring materials for drapes and curtains was presented by G. Fox & Company. There were talks on oil painting, antiques, European travel, a slide show on the efficient arrangement of kitchen cupboards, a talk on steamships and shad boats used by people of Old Saybrook and more. At the 1957 annual meeting at the Castle Inn, John Torrenti played selections from Bach, and "songs old and new were sung by all the members." The popularity of the club grew, and in 1958, the constitution was changed to increase membership from 150 to 300.

Meetings were often built around fundraising activities. There were fashion shows, arts and crafts shows, bake sales, raffles, rummage and tag sales, special events at the Ivoryton Playhouse, plant sales and a "white elephant table" where unwanted items were donated and sold to members. Funds were also raised by selling baked goods at the farmer's market, and a spring hat sale featured over two hundred bonnets at four dollars each. The largest and most successful fundraising project was the annual Apple Festival and Craft Fair. Starting in 2000 and running for the next twelve years, this autumn event often raised several thousand dollars and featured apple pies, apple cider, an apple basket raffle, food booths, children's arts and crafts, fashion shows, pumpkin

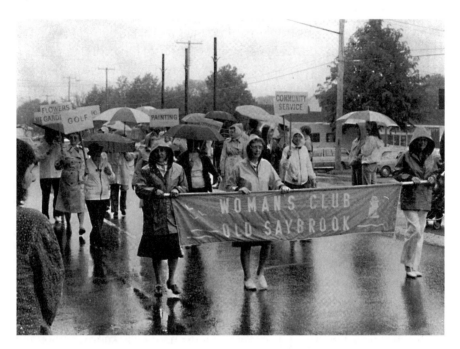

Members of the Women's Club marching in the 1994 Memorial Day parade. The club was active in civic affairs, art, music, literature and various fundraising activities. It also provided scholarships and contributed to many worthy local causes. *Courtesy of Old Saybrook Historical Society.*

This 1994 photo shows the fun times that emanated from membership in the Women's Club. As one newcomer wrote, "When people come to the town, they might like the environment, but the town is nothing until you have friends." For many, the Women's Club was the first step in making Old Saybrook a hometown. *Courtesy of Old Saybrook Historical Society.*

painting and the sale of clothing, handbags, jewelry, dolls, candles, herbal products, dried flowers, artwork, homemade pies and other seasonal goods. Members calculate that $280,000 or more has been given to good causes since the club began, and this does not include the thousands of valuable volunteer hours that have been contributed over the years.

When the Women's Club wanted to help improve the biology and botany programs and to build relationships with high school students, it gave $1,000 to buy materials for a storage shed and plantings for a high school greenhouse. Several club members decided to make a more regular commitment to the students and their science teacher, Charlie Renshaw, who was able to bring in students from other programs. The original science students began mentoring other students, and Women's Club members helped them plant flowers. The students then started a small business and provided cut flowers for teacher's desks. They grew lettuce and sprouts for the soup kitchen and sold poinsettias in December to earn additional funds. The money generated from the business was used to buy more supplies, and they began planting terrariums and delivering them to homebound senior citizens. And it all began with a timely financial contribution and the act of reaching out by members of the Women's Club.

For all their good works, solid finances and over two hundred members, club activities and programs were being handled by a dozen people who took on all leadership positions. More and more members were joining to participate in the club's special interest groups—literature, bridge, gardening and especially golf—while fewer were taking on organizational tasks. By November 2010, there were vacancies for chairperson of the program committee, publicity, recording secretary and chair of the Apple Festival. Two months later, candidates were needed to fill the positions of corresponding secretary, recording secretary and second vice-president.

The club discussed ways of increasing volunteerism among its own members but with little success. The August Farmer's Market Bake Sale had to be cancelled because no one volunteered to coordinate it. Appeals were made to members to fill officer positions, but no one came forward. Without a chairperson, the Apple Festival was canceled. Discussions among members concluded that supporting community services and scholarships were worthwhile but that there were few ideas for keeping the club viable. In November 2011, president Mary Anne Dimitry announced, "Unless the club finds new officers, the club will have to fold."

In January 2012, the search committee reported that approximately ninety members were contacted but that none were willing to accept a position on

the board or as an officer. The president announced that the board was considering disbanding by June 30, 2012. A letter to the members explained that remaining funds would be used to pay bills and make contributions. In May 2012, president Dimitry reported that she visited town hall, where the club records were stored, to decide what would be saved and what would be removed to the transfer station. A final meeting was held at the Estuary Council on June 5, 2012.

Terry Shuttleworth, a former president and longtime active member, recounted "happy memories of participation in annual arts event, apple festivals, concerts on the green, trips to interesting destinations, Tanglewood and the annual scholarship program." When asked why she thought the club was unable to survive, Terry noted that the younger women in the club had other responsibilities such as childcare and demands at home. "Some work second jobs," she said. "Some are interested in the social aspects but not necessarily the organizational aspects of the club. Everyone is different—not everyone is volunteer-minded."

President Mary Anne Dimitry says, "Gone are the days of fun, companionship, community spirit, civic and educational support for our town from WCOS. This is truly a sad occasion, not only for the members, who numbered over 250 for many years, but for the organizations and recipients who benefited from funds raised by WCOS sponsored activities."

In the attic of the Old Saybrook Historical Society, a cardboard box holding the minutes and other records of the Women's Club gathers dust, but the real record is in the people who have been helped. Inside the front cover of a record book, someone pasted an anonymous prayer:

> *Keep us, O God, from pettiness. Let us be large in thought, in word, in deed. Let us be done with criticism, pretense and prejudice, and leave off self-seeking. Grant that we may realize it is the little things that create differences—that in the big things of life we are as one. May we never be hasty in judgment and always generous. And may we strive to touch and to know the great common woman's heart of us all. And O Lord God, let us not forget to be kind. Amen.*

For more than half a century, members of the Women's Club were generous and kind and fulfilled the other admonitions of this prayer. Regrettably, there was no prayer that urged members to be leaders.

LOOKING FORWARD

REMARKABLE WOMEN ON THE WAY

Pictured here are the women who are now shaping their own lives and futures. Whatever their loyalties or national, racial, religious or ethnic backgrounds, we want them to recognize the worth of all human life. Whatever their distance from others—geographic, economic, political—we want them to realize that they are bound by common human needs, abilities and challenges.

If they make a difference by bettering the lives of others, they will advance humankind. To do so, they will need a vision that cuts across barriers, compassion and the courage to champion a worthy cause. They will inspire the best in the rest of us.

At home and in school they will learn to be competent and caring. They will be individuals who will function with sensitivity and alertness as inhabitants of a small planet. They will foster respect for individual worth and human dignity, and they will live by and promote democratic values of peace, equal opportunity, freedom and justice.

These remarkable young ladies are at the beginning of their school career. They are fortunate to attend a public school where there are caring adults in a supportive community. Their mission is to improve the future. These are remarkable women on the way.

Young ladies in the first grade at the Kathleen E. Goodwin Elementary School, Old Saybrook, Connecticut. *Courtesy of Principal Sheila Brown, teachers and parents at Kathleen E. Goodwin Elementary School, Old Saybrook, Connecticut.*

BIBLIOGRAPHY

Allis, Marguerite. *The Splendor Stays: An Historic Novel Based on the Lives of the Seven Hart Sisters of Saybrook, Connecticut.* New York: Putnam, 1942.

Booth, Elizabeth H., and Anne W. Sweet. *In the Shade of Sayebrooke Fort, 1644.* Old Saybrook, CT: Fort Saybrook Monument Park Association, 2003.

Chapman, Edward M. *The First Church of Christ in Saybrook.* New Haven, CT: Privately printed, 1947.

Chesebrough, Harriet Chapman. *Glimpses of Saybrook in Colonial Days.* Chicago: R.R. Donnelly & Sons, 1985.

Gates, Gilman C. *Saybrook at the Mouth of the Connecticut River: The First 100 Years.* New Haven, CT: Wilson H. Lee Co., 1935.

Grant, Katharine Houghton. *Marion Hepburn Grant 1918–1986, A Biography.* West Hartford, CT: Fenwick Productions, 1989.

Grant, Marion Hepburn. *Fort Saybrook at Saybrook Point.* Old Saybrook, CT: Fort Saybrook Monument Park Association, 1985.

———. *The Hart Dynasty of Saybrook.* West Hartford, CT: Fenwick Productions, 1981.

————. *The Infernal Machines of Saybrook's David Bushnell*. Old Saybrook, CT: Bicentennial Committee of Old Saybrook, 1976.

Hepburn, Katharine. *Me: Stories of My Life*. New York: Alfred A. Knopf, 1991.

Holman, Mabel Cassine. *In the Land of the Patentees: Saybrook in Connecticut*. Old Saybrook, CT: Acton Library and Saybrook Tercentenary Committee, 1935.

————. *The Western Neck: The Story of Fenwick*. Hartford, CT: Case, Lockwood & Brainard Co., 1930. Reprinted by the Old Saybrook Historical Society, 1992.

Ingham, Samuel. *Ingham Family, Or Joseph Ingham and His Descendants, 1639–1871*. Hartford, CT: Case, Lockwood & Brainard Co., 1871.

Johnson, Curtis S. *Three Quarters of a Century: The Life and Times in the Lower Connecticut Valley as Chronicled for Seventy-Five Years by the New Era*. Main Street News, 1991.

Maloney, Linda M. *The Captain from Connecticut: The Life and Naval Times of Isaac Hull*. Boston: Northeastern University Press, 1986.

Maynard, Barbara J., and Tedd Levy. *Old Saybrook*. Charleston, SC: Arcadia Publishing, 2010.

Old Saybrook Historical Society. *The Faces and Places of Old Saybrook: A Historical Album*. Old Saybrook, CT, 1985.

Petry, Elisabeth. *At Home Inside: A Daughter's Tribute to Ann Petry*. Jackson: University Press of Mississippi, 2009.

Sanford, Maria L. *Acceptance of the Statue of Maria Sanford*. Washington, D.C.: United States Government Printing Office, 1960.

Staplins, Elaine F., ed. *The Founders of Saybrook Colony and Their Descendants, 1635–1985*. Old Saybrook, CT: The Founders Committee, 1984.

Tully, William. "History of Saybrook." In *History of Middlesex County*. New York: J.B. Beers & Co., 1884.

Whitney, Helen. *Maria Sanford*. Minneapolis: University of Minnesota Press, 1922.

Wing, Richard L. *Ingham University, 1857–1892: An Exploration of the Life and Death of An Institution of Higher Education for Women*. Buffalo: State University of New York at Buffalo, 1990.

———. *Requiem for an Exemplar of Women's Higher Education: The Ingham University of Le Roy, New York, 1857–1892*. N.p., 1991.

ABOUT THE AUTHOR

Tedd Levy is a former teacher and educational consultant who now devotes much of his time to writing about local history. He is the author of *Old Saybrook: Postcard History* and the two-volume *Lessons That Work: Ideas and Activities for Teaching U.S. History* and *Souvenir Sentiments: What Teachers Told Students about Character and Country*. Levy has written numerous articles for professional and general-circulation publications on teaching history, educational issues and public affairs. A past president of the National Council for the Social Studies and co-founder of Connecticut History Day, he currently writes a weekly column for the *Shoreline Times*, serves on the board of trustees of the Old Saybrook Historical Society and is an overseer at Old Sturbridge Village.